Nicholas Watkins

MATISSE

PHAIDON

The author and publishers would like to thank all those museum authorities and private owners who have kindly allowed works in their possession to be reproduced.

Phaidon Press Limited, Littlegate House, St Ebbe's Street, Oxford
Published in the United States of America by E. P. Dutton, New York

First published 1977.

© *1977 by Phaidon Press Ltd.*

ISBN 0 7148 1804 6

Library of Congress Catalog Card Number: 77-78378.

Printed in Great Britain.

MATISSE

Matisse (1869–1954) has come to be regarded as one of the most important artists in the last hundred years. He saw himself primarily as a painter, but during a long career achieved a significant reputation as an inventive and original draughtsman, sculptor, print-maker, and designer. He thus provided in his own life an example of his concept of the professional artist as a person who can demonstrate his skill through diversification. He was a modern equivalent of the Renaissance Master, confident in his talent to create works in different media.

He is perhaps still best known as the principal protagonist of Fauvism, a movement that lasted only about five years (1904–8). Fauvism evolved from the concern of the Impressionists and their immediate successors with the aesthetic autonomy of a painting derived from nature. They wished to realize an art of pure colours, which would at the same time represent the subject and achieve a pictorial equivalent of the sensation generated by the subject. It can be seen as a twin reaction against photographic realism and the polished perfection of sophisticated Academic art, and as an enforced concentration on the expressive potential of the traditional means at a painter's disposal – canvas surface, quantity and quality of paint, brush-mark, and line.

The exuberant immediacy and impact of such Fauve paintings as *Landscape at Collioure* (Plate 10) is still tremendously appealing; but Matisse's Fauvism should be seen in the context of his work as a whole. A fuller appreciation of his art requires the recognition of the deep unity of intention and feeling underlying it, recognition that can come only through a knowledge of his early work and the way in which it evolved through its successive stages.

His work was characterized by three elements: it expressed his personality, it involved dedicated hard work and it aimed at the creation of tranquillity in the mind of the onlooker. Matisse expressed the first of these elements succinctly in an interview with the poet Apollinaire in 1907: 'I found myself or my artistic personality by looking over my earliest works. They rarely deceive. There I found something that was always the same and which at first glance I thought to be monotonous repetition. It was the mark of my personality which appeared the same no matter what different states of mind I happened to have passed through'. The permanence of personality is something which Matisse patiently sought to recognize in his art, and not without great labour. He distrusted the spontaneous statement, the happy accident that illuminates and dazzles the mind, and wanted, as he stated in his influential *Notes of a Painter* in 1908, 'an art of balance, of purity and serenity, devoid of troubling or depressing subject matter, an art which could be for every mental worker, for the businessman as well as the man of letters, for example, a soothing, calming influence on the mind, something like a good armchair which provides relaxation from physical fatigue'.

The image of art as a boardroom palliative is perhaps unfortunate in that it disguises the real, revolutionary nature of Matisse's proposition.

What Matisse advocated, and in fact achieved, was the active involvement of the spectator in the whole chromatic substance of a painting's surface. Painting was no longer to be seen as an illustration or an illusion in the centre of the canvas. To learn to look at a

Matisse is to subject oneself to the full impact of paint, and to be able to respond to subtle nuances in handling, ranging from thick impasto highlights to washes gently stroked on to allow the ground to breathe through. Matisse summed this up in 1945: 'The characteristic of modern art is that it participates in our life. A painting in an interior spreads joy around it by the colours which calm us. The colours obviously are not assembled haphazardly but in an expressive way. A painting on a wall should be like a bouquet of flowers in an interior. These flowers are an expression, tender or passionate'.

The coupling of seriousness of intent with a highly decorative means of expression resulted in a new category of art, the decorative easel painting. Far from being merely decorative in a pejorative sense, Matisse allows us to follow his struggle through in the process leading up to a balance of forces in a painting, to a point of harmony where the final experience is one of pure joy.

As with many totally dedicated artists, Matisse's life can be characterized as a chronology of involvement with his work. He tended to exclude any relationships or outside interests that impinged too closely on his time. 'One must make a choice in life', he explained, 'either paint or go out in the world. But one cannot do both things at the same time.' His working life was for the most part divided between Paris and Nice with important journeys to Corsica in 1898, Algeria in 1906, Italy in 1907 and 1925, Munich in 1910, Moscow in 1911, Morocco in the winters of 1911–13, and Tahiti in 1930.

Surprisingly little is known about his family background and formative years. He was born on 31 December 1869 at Le Cateau-Cambrésis in Picardy. His father was a grain merchant at nearby Bohain-en-Vermandois. Matisse studied law in Paris in 1887–8, and from 1889 until his return there in 1891 to study painting he worked as a clerk in a lawyer's office at St. Quentin, the main town of his home district. It appears to be specially significant in retrospect that he began to paint in 1890 during a prolonged period of convalescence after appendicitis. 'Then I was free, solitary, quiet', he said later, 'whereas I had always been rather anxious and bored in the various things I was forced to do'. This anxiety and the wish to perpetuate the comforting feminine warmth of the silent sickroom remained throughout his life as two contrasting features of his personality; they could only be resolved in compulsive and perpetual work.

Matisse spent almost a decade as an art student within the academic system. He attended drawing classes at the art school in St. Quentin in 1889, and then entered Bouguereau's class at the Académie Julian in Paris in 1891, before working in the sympathetic studio of Gustave Moreau at the École des Beaux-Arts, at first unofficially and then officially after the entrance examination of February 1895. He remained in Moreau's studio until his marriage and sojourn in the south in 1898. He returned to Paris in 1899 to find that Moreau had died. Moreau's successor, Cormon, soon eased Matisse out of the studio, apparently because of his age. He attended life classes at the Académie Carrièreh, where he met André Derain, his future collaborator in Fauvism, and studied sculpture in the evenings at a municipal school.

This long and patient apprenticeship however did not breed in him a spirit of emulation, but rather provided him with what he later liked to regard as an established dogma against which he continued to react. 'These rebellions', Matisse wrote in 1951, 'led me to study separately each element of construction: drawing, colour, values, composition; to explore how these elements could be combined into a synthesis without diminishing the eloquence of any one of them by the presence of the others, and to make constructions from these elements with their intrinsic qualities undiminished in

4

combination; in other words, to respect the purity of the means'.

This statement, however, does not acknowledge the crucial influence of Moreau's teaching. The jewel-encrusted world of Moreau's paintings inspired a new vision through the imaginative handling of colour, rather than through their subject-matter. He enjoyed the respect and affection of his students, and his methods as a teacher were liberal and contributed to the development of some of the greatest colourists of the next generation. He wanted to inspire his students with the vision of an art that would transcend naturalistic description and lead the spirit towards an ideal of beauty and perfection. 'Note one thing well', he said to a student, 'if you want to think in terms of colour, you have to have imagination. If you have no imagination you will never be a good colourist. It is necessary to copy nature with imagination: that is what makes an artist. Colour ought to be thought, dreamed, imagined'. (A philosophy that was in contrast to the academic concentration on the primacy of drawing to the exclusion of teaching on colour.) This is not to say that Matisse did not believe in the guiding role of drawing, as he explained in 1948: 'I believe study by means of drawing to be essential. If drawing belongs to the realm of the Spirit and colour to that of the Senses, you must draw first to cultivate the Spirit and to be able to lead colour through the paths of the Spirit.' But it was Moreau's concept of colour as belonging to the imagination which set Matisse on the path to the great decorative work of his maturity.

Despite the originality of his decorative work, however, Matisse believed that art should be based on reality. His first, modest paintings were concerned with the depiction of objects and situations that he knew well, using a restricted palette. *Interior with a Top Hat* (1896, Plate 1) should not be dismissed too readily as an awkward inventory of objects: it does show that Matisse was experimenting with an interesting organization of pictorial depth which would allow him to portray the reality of the object without losing atmosphere.

His adoption of the rainbow palette came with his second summer trip to Brittany in 1896 and his introduction to Impressionism by Emile Wéry, a now forgotten painter. Matisse remarked in 1925: 'I then had only bistres and earth colours on my palette, whereas Wéry had an Impressionist palette. Like him, I began to work from nature. And soon I was seduced by the brilliance of pure colour'. Matisse further explored the new technique by the cliffs of Belle-Isle in 1897. *Rocks and the Sea* (1897, Plate 2) can be seen as a typical Impressionist landscape – small in format for outdoor working, informal in composition, and with the high-keyed palette and all-over choppy brushwork to convey the palpitating effect of light over the whole surface.

Matisse's contact with Modern Art in the form of Impressionism gave him a new-found freedom to experiment in a series of landscape studies with different types of brushmark and often explosive combinations of colour. He soon realized that the individual brushmark of pure colour contained an emotive impact over and above its descriptive function, and that he needed an art that could synthesize fleeting sensations into a more permanent statement. The much-loved myth of Modern Art about the instantaneity of Impressionism should not obscure Matisse's permanent debt to it. He derived from it his belief in art as a celebration of what gives pleasure in life, and in the feeling that the finished painting should convey the freshness and immediacy of the first glance.

Between 1899 and 1904 he worked in a variety of styles on a prophetically limited range of subjects – still lifes, nude studies, and Seine views, with the occasional studio interior,

portrait, costume piece, or landscape. He set in being the single-minded obsession with a problem which could only be resolved in the rephrasing of it from painting to painting. His Turneresque *Sunset in Corsica* of 1898 had revealed the inadequacy of representing light by depicting the sun itself, and that somehow its vibrant energy had to be recreated on the picture surface without a consequent lack of structure.

This problem had already been faced by others. The Neo-Impressionists had striven for a structural, atmospheric art based on dots of pure colour (a technique referred to variously as Divisionism and Pointillism). Matisse was probably influenced by them when he painted the overladen *Sideboard and Table* (1899), now in Washington, congested in a complex matrix of dots. *Still Life with Oranges* (*c.* 1899, Plate 46) might have been a study for this painting but is more likely to represent a subsequent expansion of the Neo-Impressionist dot into areas of pure colour a mixed technique that anticipates the Fauve paintings by five years).

The paint surface in Matisse's early still lifes is often densely worked, owing much to Cézanne, who showed the way in which the light of Impressionism could be given permanence without loss of form, structure, or chromatic substance. Cézanne was without doubt the most important single influence on Matisse. 'If you only knew', Matisse said in 1925, 'the moral strength, the encouragement that his remarkable example gave me all my life! In moments of doubt, when I was still searching for myself, frightened sometimes by my discoveries, I thought: "If Cézanne is right, I am right"; because I knew that Cézanne had made no mistake'. At this critical moment in his career Cézanne gave him the courage to distance himself from Impressionism and tackle one of the greatest themes in European art: the posed nude. *Male Model* (1900, Plate 4) is sculptured in colour in a truly plastic space, and Matisse pursued the exploration of the volumes of this figure in clay. And in paintings ranging from *Pont St. Michel* (1900, Plate 6) to *The Path in the Bois de Boulogne* (1902, Plate 7), he invested Impressionist compositions with the permanence of atmosphere and surface solidity of Cézanne.

The slow tonal build-up in *The Path in the Bois de Boulogne* allowed the warm colours – alizarin pink, cadmium orange, and chrome yellow – to be played as chromatic accents in brushstrokes of remarkable freedom. Matisse increasingly wanted to construct in terms of pure colours and recapture the luminosity of Impressionism; and Signac's intention to achieve 'the maximum luminosity, colouration, and harmony' in his painting must have appealed to Matisse, who in 1904 went south for the second time and stayed with him at St. Tropez to study Neo-Impressionism, a technique he was soon to abandon. 'Neo-Impressionism, or rather that part of it called Divisionism', Matisse recalled in 1929, 'was the first systematization of the means of Impressionism, but a purely physical systematization, an often mechanical means corresponding only to a physical emotion. The breaking up of colour led to the breaking up of form, of contour. Result: a jumpy surface. . . . Everything is treated in the same way. Ultimately, there is only a tactile vitality comparable to the "vibrato" of the violin or voice'. Matisse's statements on art have the persuasive finality of an eminent professor summing up a lecture, but should not necessarily be taken as the last word on problems faced twenty-five years before. At the time, Neo-Impressionism gave him the means to construct in pure colour.

Luxe, Calme et Volupté (1904, Plate 11) stands as a summary of all that Matisse had learnt from Neo-Impressionism, and the subject-matter – the 'earthly paradise' – takes up one of Signac's favourite themes. The setting is recognizable as the view across the sea to the mountains from the beach below Signac's house. The female nudes were not in fact posed

in the open air. Matisse had done three student copies after Poussin which had introduced him to the possibilities of a monumental figurative art, and the bathers theme had recently been taken up by (among others) Cézanne, Renoir and Signac. The title comes from the repeated refrain of Baudelaire's poem *The Invitation to the Voyage* – 'Everything there is harmony and beauty, luxury, tranquillity, and delight'. An academy of nudes about to break off for tea has little to do with the poem, which evokes an imaginary interior that offers the calm and contentment the poet could never find in life. The poem suggested atmosphere to Matisse rather than subject-matter (though it is interesting to note that this short poem, and the prose poem on the same subject, set out a programme for Matisse's Nice interiors of the 1920s: 'The mirrors, metals, draperies, the plate and ceramics there perform for the eyes an unheard and mysterious symphony; and from every object, every corner, from the chinks in the drawers and the hangings' folds, there emanates an uncommon aroma, a whiff of Sumatra, which is like the apartment's soul'). *Luxe, Calme et Volupté* might appear awkward in its slightly laboured exploration of technique, and ultimately remote, but it does herald the imaginary subjects of Matisse's maturity.

Neo-Impressionism had liberated Matisse's palette; Van Gogh and Gauguin had shown ways of portraying nature in expressive brushstrokes and flat planes of saturated colour; and in the summer of 1905 at the small port of Collioure by the Spanish border he attempted with Derain to come to grips with these different styles under a broadly Impressionist aesthetic. The result was a new style: Fauvism (a name coined after a critic termed Matisse and other like-minded artists '*les fauves*' – wild beasts). Fauvism was a summation of the past as well as a portent of the future. 'Here are the ideas of that time', Matisse recalled in 1929. 'Construction by coloured surfaces. Search for intensity of colour, subject-matter being unimportant. Reaction against the diffusion of local tone in light. Light is not suppressed, but is expressed by a harmony of intensely coloured surfaces'. It is worth emphasizing that Matisse's Fauvism – popularly seen along with other Fauvist art as highly artificial – was stimulated by contact with the real world, as Impressionism was.

Open Window, Collioure (1905, Plate 9) is one of the most ravishingly beautiful of the Fauve paintings. Its structure is created by pure colour. The window is locked between planes of magenta-pink and blue-green which suggest light and shade in the interior. The vermilion red and its complementary green on the balcony, acting like the notes of a major chord, are linked to the background by the echoing magenta-pink and blue-green of sand and sea. Ultramarine blue stabilizes the central axis and sets off the solar orange. The technique varies enormously from thin washes to an impasto stroke of white on the light-giving, exposed ground of the canvas in the horizon; such devices create depth. The window motif continued to fascinate Matisse, as he explained in 1942: 'the space is one unity from the horizon right to the interior of my work room, and the boat which is going past exists in the same space as the familiar objects around me, and the wall with the window does not create two different worlds'.

Fauve paintings are for the most part small in scale, suitable for working before the subject like Impressionist landscapes, and in the winter of 1905–6 Matisse rented a large studio and synthesized his discoveries into a monumental decorative work, *Bonheur de Vivre* (Joy of Life). *Bonheur de Vivre* is a key work in Matisse's evolution, and it is to be regretted that the regulations of the Barnes Foundation in Merion, Pennsylvania, do not permit the reproduction of their paintings in colour. Nothing can prepare one for the chromatic shock of the work. Broad areas of pure, flat colour are articulated by sinuous arabesques to

provide the setting for a harem of Oriental women in the West. A solitary little piping shepherd looks back over his shoulder like a voyeur as he leaves them to luxuriate in the joy of life. A ring of figures tread out a dance by the sea, emphasizing the posed immobility of the nudes in the foreground. The subject-matter owes something to Gauguin's Tahitian paintings, which Matisse had seen at the home of Daniel de Monfried near Collioure in the summer of 1905.

In 1907 Matisse began a series of great decorative figure compositions which developed the theme of nudes in a universal landscape. His visit to Biskra in Algeria in 1906 confirmed his feeling for Oriental decorative art, and in 1907 he went to Italy and established contact with the European tradition of monumental mural decoration flowing from Pompeii and the mosaics of Ravenna to Giotto, Piero della Francesca and Veronese. It was his unstated programme in the next few years to unite these two traditions – the Oriental and the European – in a new figurative art which would present an ideal state of being as experienced fact.

Few painters have had the courage to set out on such a programme, and Matisse characteristically went about it in a methodical way. In his *Notes of a Painter*, published in 1908, he said: 'What interests me most is neither still life nor landscape, but the human figure. It is that which best permits me to express my almost religious awe towards life'. The sensuously rhythmic outline drawing of the figure in *Bonheur de Vivre* seduced the eye but did not concentrate attention. In his search for the means to suggest what he called 'the deep gravity which persists in every human being', he turned again to sculpture and the art of Cézanne. In his insistence on the primacy of the figure in his work Matisse might have been responding to the challenge set by Picasso, but it is more likely that he had now got the confidence to stamp his personality on the subject that had absorbed the greatest painters in the past. 1907 can be regarded as an exploratory year in which, in paintings like *The Blue Nude,* he came as close as he could to realizing sculpture in painting.

Bathers with a Turtle (1908, Plate 13) marks the beginning of Matisse's maturity as a painter, and presents an image in which details like the beach towels, boats, and reflections in the *Three Bathers* (1907) have been excluded in the interests of harmony. 'When I see the Giotto frescoes at Padua', Matisse said in 1908, 'I do not trouble myself to recognize which scene of the life of Christ I have before me, but I immediately understand the sentiment which emerges from it, for it is in the lines, the composition, the colour. The title will serve only to confirm my impression'. The subject-matter of harmony is not the product of a literary programme, but is the outcome of a rigorous and lengthy process in which the pictorial elements are worked into an accord. The turtle crawls in as a complementary accent, red against green, to focus attention, and initiate the circular rhythm which unites the three similar bathers in different positions silhouetted by coloured contours against the triple bands of land, sea, and sky. Everything appears to be in exactly the right place. Numerous sources have been suggested for each expressive distortion of reality, but they have been as thoroughly absorbed in this painting as the mound which formerly supported the seated nude on the right.

The opportunity to complete this monumental decorative theme of figures suspended in a state of harmony came with the commission from the Russian merchant, Sergei Shchukin, to execute two large paintings, *Dance* (1909–10) and *Music* (1910), for the stairwell of his mansion in Moscow. Both paintings develop stylistically from *Bathers with a Turtle* and originate from similar subjects in his earlier work. The source for the *Dance* is to

be found in the circle of dancers by the sea in *Bonheur de Vivre*, and that of *Music* in *Music* (sketch) (1907). Shchukin is known to have admired *Bathers with a Turtle*, and it has been suggested that the great *Bathers by the River* (1916/17) in Chicago was to have been a possible third decorative panel for him. In *Dance* and *Music* composition, colour, and form are closely related to content. 'The colour was proportioned to the form,' Matisse said. 'Form was modified according to the reaction of the adjacent areas of colour. For expression comes from the coloured surface which the spectator perceives as a whole'. Nobody who has stood before these sublime surfaces can doubt that they are imaginative *tours de force*.

It was only to be expected that after the imaginative heights of *Dance* and *Music* Matisse would patiently re-assess his roots by looking back over his past work and by returning to the source of his art in the sensation of reality. Both approaches were combined in 1911 in the large studio interiors, *Red Studio* and *Pink Studio*, but the principal stimulus of these years came with his visits to Morocco in the winters of 1911–12 and 1912–13. 'The voyages to Morocco', Matisse recalled in 1951, 'helped me accomplish this transition, and make contact with nature again better than did the application of a lively but somewhat limiting theory, Fauvism'. Morocco helped to bridge the gap between reality and the dream, and his study of Oriental art suggested the means to transcend the hermetic world of the intimate interior. 'Once my eyes were unclogged', Matisse explained, 'I was capable of really absorbing the colours because of their emotive power. . . . Persian miniatures, for example, showed me all the possibilities of my sensations. I could find again in nature what they should be. By its properties this art suggests a larger and truly plastic space. That helped me to get away from intimate painting'.

The paintings of the North African period combine fidelity to the motif with imaginative colour. *Window at Tangier* (1912, Plate 20), for example, shows a view from his bedroom in the Hôtel de France over the gardens and pink paths to the English church with its green roof and Tudor Tower; and in this stunningly beautiful painting the red vase with flowers floats as a chromatic accent in a monochromatic mirage of blue. Yet beneath the heady, highly perfumed atmosphere of *Window at Tangier* there persists that deep underlying gravity which Matisse was to express so successfully in the war years.

With the coming of war, the reverie of the Orient was broken by a new objectivity. It was as though Matisse doubted his ability to perpetuate sensation in troubled times. He began to concentrate on subjects over an extended period in order to find stability. In part, this involved taking account of the surface of the painting as an object in its own right. This concern he shared with the Cubists, who pioneered the dialogue between subject and surface. Matisse described this concern with typical clarity: 'The Cubists' investigation of the plane depended on reality. In a lyric painter, it depends on the imagination. It is the imagination which gives depth and space between objects. From another viewpoint, Cubism is a kind of descriptive realism'. The deeply moving *Portrait of Madame Matisse* (1913, Plate 21) marks the transition between the lyricism of Morocco and the new structural solemnity of *The Painter and His Model* (1917, Plate 25). *Composition, Yellow Curtain* (1915, Plate 19), which is a view through the window of the oval pool in his garden, is the nearest Matisse ever came to the creation of a new, colourful, curvilinear form of Synthetic Cubism.

It is evident from Matisse's published statements on art that he regarded the quiet tonal colours of his beginnings as somehow more truthful to reality, yet less capable of

stimulating the imagination. The return to objectivity brought back the blacks, ochres, and siennas to his palette. The black balcony in *The Painter and his Model* (1917, Plate 25) leads the eye into a vertical plane of pale sienna. In a state of unease he was perhaps seeking security in the substance of solidly worked earth colours. He admired Manet's ability to create light with black, but when it came to painting nature he often reverted to the lighter palette pioneered by the Impressionists. He maintained both modes in *The Window* (1916, Plate 27), but as his mood changed with the end of the war he began to think more in terms of light, pure colour, and outdoor working. This intimacy with nature, he told a friend, helped calm his nerves, and the numerous small landscapes that he did in these years would form an interesting exhibition showing yet another facet of this great talent.

Tea (1919, Plate 30) bridges the gap between his small landscapes and large-scale interiors. Light percolates down through the trees on to the path in his garden at Issy-les-Moulineaux, a suburb of Paris, where his daughter and a model are having tea. The painting celebrates the relaxed atmosphere of his domestic milieu as a subject for art. A shoe is suspended nonchalantly from his daughter's toes. A dog scratches itself.

Light was becoming increasingly the artist's obsession, and each winter since 1916 his departure for Nice took on more noticeably the nature of a pilgrimage in a quest to make permanent the sensations of the south. On being asked by the poet Aragon what made him choose Nice, Matisse replied: 'In my art I have tried to create a setting that will be crystal-clear to my mind', and then he goes on to say: 'If I had gone on painting up north, as I did thirty years ago, my painting would have been different; there would have been cloudiness, greys, colours shading off in the distance'. He acknowledged that light provided the primary inspiration in his painting and was the source of colour, and in this he drew close to the Impressionist position again. He visited the aged Renoir at Cagnes near Nice in 1917, and it was probably the example of that master which gave him the confidence after the war to paint only what gave him pleasure.

The Artist and his Model (1919, Plate 31) is a glorious painting which anticipates many of his artistic concerns during the 1920s. The artist at work looks across a bowl of flowers on a striped tablecloth at a nude model reclining in an armchair. Through the window, lightly veiled with a net curtain accented with pale brown flowers, is seen the crest of a fecund date palm. A green vase of flowers, echoing the shape of the model, sits on the dressing-table to the right, and mirrors add ambiguity to a seemingly simple composition. In colour, it is a symphony in subtle hues – pinks, violets, watery blues, pale ochre and sienna browns. In contrast to an Impressionist composition it contains repetitions of shape and colour which work together to create the quiet poetry of the interior. Twenty years after leaving this room in the Hôtel de la Méditerranée Matisse recalled its charm: 'I stayed there four years for the pleasure of painting nudes and figures in an old rococo salon. Do you remember the way the light came through the shutters? It came from below like footlights. Everything was fake, absurd, terrific, delicious'.

His interest in light slowly gave way to a concentration on the physicality of colour and the solidity of the female form. The transient dream of a room of earthly delights was now made as durable as possible. The frontal nude in *The Hindu Pose* (1923, Plate 32) is suspended in a field of blue activated by flickering dots to set off the firmness of her flesh. Interesting objects have been removed from the room, the view out through the window has been sealed off in colour, and pictorial depth is restricted. Nothing, not even the

expression on the woman's face, is allowed to interfere with the observance of her body. Sensual pleasure is sublimated in the handling of paint, and the model is left looking curiously detached, or even a little bored. It is possible to see this as a magnificent image of spiritual boredom in the tradition of Delacroix's odalisques.

As in 1907, Matisse's concern for solidity was accompanied by a renewed interest in sculpture, but the problem had changed. He was now not concerned to find volume but to lose it in an arabesque which would at the same time suggest form and assert the surface. *Woman with a Veil* (1927, Plate 33) is a powerful painting on which the history of the struggle between figure and ground is commemorated in the scoured paint surface. The constant preoccupation with light and shade is represented in the juxtaposition of red against green, and the only soft note is struck in the background with the milky blue and pink enlivened by a short bar of orange. Pattern is introduced not to charm by its variety, but to contradict form and assert the two-dimensionality of the picture plane.

Changes in Matisse's painting came to the surface only after profound deliberation of an alternative, which had been perhaps developing subconsciously over a long period. He was very much aware of the kind of respectable revolutionary source that it was safe for an established Master of Modern Art to acknowledge in public statements; and therefore the decorative tradition he now turned to, stemming from Raphael, Michelangelo, the Mannerists, and Ingres, has not been given due attention in the extensive literature on his art. The aspect of this tradition which he took up was essentially concerned with the linear arabesque of the figure. He had been drawing from casts of Michelangelo's sculpture at least since 1918, and in fact had a cast of the *Dying Slave* in his studio in the 1920s. By 1930 Matisse was recognized, along with Picasso, as one of the two emperors of an unstable art world, and it was therefore appropriate that in the next decade he should develop a slightly detached but magnificently decorative courtly style. The grand opportunity to give it expression came with the commission to do a mural for the three lunettes above the french-windows in the main hall of the Barnes Foundation, Pennsylvania.

The Barnes mural is, like *Bonheur de Vivre* in the same collection, a key work in Matisse's oeuvre. The relationship between the two is revealing, for in *Bonheur de Vivre* is seen for the first time the ring of dancers and flat colour articulated by line which developed into the subject-matter and style of the mural. The gestation of this new *Dance* was lengthy, complex, and even now is not fully understood. Matisse finally accepted the commission in January 1931 and was nearing completion in 1932 when he found that the measurements he had been given were wrong. Instead of adding a surrounding border to fit the lunettes he did a new variation on the theme with eight dancers instead of six; this was completed in April 1933. The change between the two versions is not to be accounted for in differences of style, but in terms of suitability for the architectural context. Matisse was a perfectionist, and he must have realized that the shape of the arches had to find a more convincing echo in the curves within the composition if the dynamic relationship between figure and field was to be strengthened.

Nothing was wasted in his art, and it now seems certain that he returned to work on the first version once the second was installed. *The Dance* (first version, 1931–33, Plate 38) shows the panel for the left-hand lunette, in which the curves of the dancers play in counterpoint to the rhythm of the bands of colour in the background. There is a markedly new majestic independence of the pictorial elements – figure, ground, line, and colour, which was in part facilitated by the new techniques he used to gain possession of this vast surface. The dancers were drawn in charcoal attached to a long bamboo, and the colours,

as Matisse related, 'were tried out not by painting on the canvas but by cutting out sheets of painted paper which were then fastened to the canvas around the contours of the figure. These too had to be changed again and again as the composition developed'. The flexibility of this new process led to an increased purity of means so that the dialogue between the individual elements became part of the content of the work.

The easel painting of the 1930s are primarily concerned with drawing, and with the expressive distortion of the female form to characterize a mood in accordance with the model's personality – the length of her languid repose, for example, or the profundity of her dreaming. The model on a sofa in *Pink Nude* (1935, Plate 37) evolved in twenty-two states, documented in black-and-white photographs, from a more naturalistic study of a reclining nude in a large room to an enclosed hieratic image of ease. From the sixth photographed state Matisse began to expand the figure out in pinned paper until the forms filled the surface with the full weight of relaxation. The colours of *The Dance* had been restricted so as not to destroy the two-dimensionality of the supporting wall, or conflict with the paintings and the colours seen in the garden through the french-windows. This role of colour to advertise and emphasize shape in a simplified palette was continued in *Pink Nude* and in the other paintings of the 1930s with an ever-increasing heraldic intensity and subtlety.

Lady in Blue (1937, Plate 42) is probably the most magnificent of Matisse's court portraits. It is of his secretary Lydia Delektorskaya, the organizer of his studio. She is given the voluminous sleeves and waisted flowing robe of the Raphaelesque portrait of Giovanna of Aragon, which he knew in the Louvre; and the enormous floppy, protective hand with the rosary provocatively emphasizes her queenly untouchability. Characteristically, he began with a more naturalistic portrait, which became progressively more abstract with each successive state until a perfect balance was achieved between line and colour. Colour was no longer used just to fill in contour, but was materialized to the point where it could take on part of the representational function, allowing line to etch out a more autonomous existence, light against dark or dark against light.

The independence of line stimulated in Matisse the desire to recapture that inventive spontaneity present in the long process leading up to a painting. In 1940 his drawing began to separate from his painting, and in 1941 he concentrated almost exclusively on a long series of 158 drawings, divided into seventeen groups, called 'Themes and Variations'. Each drawing was considered as an individual work of art and was preceded by numerous studies. White as the summation of colour became an idealized substance into which the figure was drawn in relation to the page. 'My line drawing', Matisse said in 1939, 'is the purest and most direct translation of my emotion. The simplification of the medium allows that. And at the same time, these drawings are more complete than they may appear to some people who confuse them with a sketch. They generate light; seen on a dull day or in indirect light they contain, in addition to the quality and sensitivity of line, light and value differences which quite clearly correspond to colour'. The freedom in these drawings shows how an almost pantheistic identification with his subject gave him the knowledge to find the right line to resemble the form.

He maintained contact with colour in a series of paintings of women in interiors and still lifes. *Dancer and Armchair, Black Background* (1942, Plate 40) juxtaposes the two themes in the opposition of blue against yellow on black. Drawing and colour followed parallel paths towards autonomy. Each colour became increasingly to be considered as an individual note to be sounded out with the greatest possible clarity in the composition.

After his recovery from two major intestinal operations in 1941 he became filled with the urge to escape the claustrophobic confines of his bed into a vision of pure colour and line interacting in the remembered crystalline light of his journey to Tahiti in 1930. The technical solution that enabled him to unite line and colour came with the elevation of the pinned cut-out paper from being an aid in the gestation of a painting to the primary substance out of which the work was formed. Matisse had sheets of paper painted in gouache and then cut directly into the colour. The resulting shapes could be changed and moved in the process leading up to the point when they were finally fixed down on a support. He had tried out the technique in 1937 for the cover of the first issue of the magazine *Verve*, but the first sustained use of it came in his book of 20 picture poems balanced by a hand-written text called *Jazz*, 1943–47. 'The paper cut-out', Matisse explained in 1951, 'allows me to draw in colour. It is for me a matter of simplification. Instead of drawing the contour and filling in the colour – one modifying the other – I draw directly into the colour, which is all the more controlled in that it is not transposed. This simplification guarantees a precision in the reunion of the two means which brings them together as one'.

The opportunity to crown his life's work with a total art work which would unite light, colour, drawing, and sculpture in architecture came with his undertaking to design a new chapel for the Dominican Sisters at Vence. The Vence Chapel (1947–51) could be seen as evidence of Matisse's final rapprochement with Christianity. He had always understood the historical importance of the continuity of faith in the West symbolized by the Catholic Church; but his own preoccuptation was not with sin and guilt but with life and the disciplined Oriental understanding of the pleasures that make it worth living. It is significant that he saw Chartres and the Orient coming together in the stained-glass windows of the Vence Chapel. 'My only religion', he said in 1952, 'is the love of the work to be created, the love of creation, and great sincerity'. The Chapel is therefore to be seen as a votive offering for the gift of life given him by the doctors and sisters after his operation in 1941, and ultimately as a temple of light, a monument to his own creative ego.

Matisse's oeuvre had been marked by the polarity of his early work between the observed and the imagined, and it was only in his final years that he could keep both modes going at the same time with the perfect conviction that they stemmed from his own response to the materials and situations he had grown to understand. *The Silence Living in Houses* (1947, Plate 44) takes up the theme of figures in an interior and combines it with simplicity of colour and shape. *The Snail* (1953, Plate 47) returns to the circular rhythm of life which informed his greatest decorative works and presents it as a final testament of faith in the power of pure colour. Few painters have ever been able to fulfil their potential; Matisse did, and it is fitting that one of his last statements on colour should serve as his epitaph: 'Colours win you over more and more. A certain blue enters your soul. A certain red has an effect on your blood-pressure. A certain colour tones you up. It's the concentration of timbres. A new era is opening'.

Outline Biography

1869 Born at Le Cateau-Cambrésis in Picardy.

1886–8 Studies law in Paris.

1889 Becomes a clerk in a law office at St.-Quentin.

1890 Begins to paint while convalescing from appendicitis.

1891 Studies painting under Bouguereau at the Académie Julian in Paris.

1892–8 Studies under Gustave Moreau at the École des Beaux-Arts.

1898 Marries. Visits London and then spends twelve months in Corsica and Toulouse.

1899–1904 Paints in a variety of styles influenced mainly by Cézanne.

1904 Spends summer with Signac at St.-Tropez and experiments with the Neo-Impressionist technique.

1905–8 Combines the influences of Post-Impressionism in his Fauve style.

1906 Visits Biskra, Algeria.

1907 Visits Italy.

1909 Commissioned by the Russian merchant, Shchukin, to paint *Dance* and *Music*.

1911–13 Spends the winters in Morocco.

1916 Begins spending the winters in Nice.

1930 Visits Tahiti; receives the commission to do *The Dance* for the Barnes Foundation.

1941 Survives two serious intestinal operations.

1951 Completes the Vence Chapell, which he sees as the culmination of his life's work.

1954 Dies in Nice.

Bibliography

Aragon, Henri, *Matisse: a novel*. Collins 1972 (2 vols).

Barr, Alfred M., *Matisse: His Art and His Public*. The Museum of Modern Art, 1951. (Recently republished by Secker and Warburg.)

Diehl, Gaston, *Henri Matisse*. Éditions Pierre Tisné, 1958.

Elsen, Albert E., *The Sculpture of Henri Matisse*. Abrams, 1972.

Escholier, Raymond, *Matisse from the Life*. London, 1960.

Flam, Jack D., *Matisse on Art*. Phaidon, 1973.

Fourcade, Dominique, *Henri Matisse: Écrits et propos sur l'art*. Hermann, 1972.

Gowing, Lawrence, *Matisse 1869–1954*. A retrospective exhibition at the Hayward Gallery, 1968.

Guichard-Meili, Jean, *Matisse*. London, 1967.

Schneider, Pierre, *Henri Matisse*. A retrospective exhibition at the Grand Palais, 1970.

List of Plates

1. *Interior with a Top Hat.* 1896. Canvas, 80 × 94·9 cm. Paris, Private Collection.

2. *Rocks and the Sea.* 1897. Canvas, 65·1 × 54 cm. Paris, Private Collection.

3. *Interior with Harmonium. c.*1900. Paper on panel, 73 × 55·2 cm. Nice-Cimiez, Le Musée Matisse.

4. *Male Model.* 1900. Canvas, 100 × 73 cm. New York, Private Collection.

5. *Japanese Lady.* 1901. Canvas, 116·8 × 80 cm. Paris, Private Collection.

6. *Pont St. Michel.* Paris, 1900. Canvas, 64·8 × 80·6 cm. New York, Mr. and Mrs. William A.M. Burden.

7. *Path in the Bois de Boulogne.* 1902. Canvas, 62·9 × 79·1 cm. Moscow, The Pushkin Museum of Fine Art.

8. *Corner of the Studio, c.*1900. Canvas, 54·6 × 45·7 cm. London, Lord Amulree.

9. *Open Window, Collioure.* 1905. Canvas, 55·2 × 46 cm. New York, Mr. and Mrs. John Hay Whitney.

10. *Landscape at Collioure.* 1905. Canvas, 59·4 × 73 cm. Leningrad, The State Hermitage Museum.

11. *Luxe, Calme et Volupté.* 1904–5. Canvas, 98·4 × 118·4 cm. Paris, Private Collection.

12. *Nymph and Satyr.* 1909. Canvas, 88·9 × 117·2 cm. Leningrad, The State Hermitage Museum.

13. *Bathers with a Turtle.* 1908. Canvas, 179·1 × 220·3 cm. United States, The City Art Museum of Saint Louis, Missouri (Gift of Mrs. and Mrs. Joseph Pulitzer, Jr.).

14. Detail of Plate 13.

15. Detail of Plate 31.

16. *Girl with a Black Cat (Marguerite Matisse).* 1910. Canvas, 94 × 64·1 cm. Paris, Private Collection.

17. *Riffian Standing.* 1912. Canvas, 146·1 × 98·1 cm. Leningrad, The State Hermitage Museum.

18. *Open Window, Collioure.* 1914. Canvas, 116·8 × 90·2 cm. Paris, Private Collection.

19. *Composition, The Yellow Curtain.* 1915. Canvas, 146·1 × 97·2 cm. Brussels, Monsieur Mabille.

20. *Window at Tangier.* 1912. Canvas, 114·9 × 79·4 cm. Moscow, The Pushkin Museum of Fine Art.

21. *Portrait of Madame Matisse.* 1913. Canvas, 147 × 97·2 cm. Leningrad, The State Hermitage Museum.

22. *The Italian Woman.* 1915. Canvas, 116·2 × 89·5 cm. New York, Private Collection.

23. *Portrait of Michael Stein.* 1916. Canvas, 67·3 × 50·5 cm. The San Francisco Museum of Art (Gift of Nathan Cummings).

24. *The Green Robe.* 1916. Canvas, 73 × 54·6 cm. New York, Private Collection.

25. *The Painter and his Model.* 1917. Canvas, 146·1 × 97·2 cm. Paris, Centre Georges Pompidou.

26. *Madame Greta Prozor.* 1916. Canvas, 146·1 × 95·9 cm. New York, Private Collection.

27. *The Window.* 1916. Canvas, 146·1 × 116·2 cm. The Detroit Institute of Arts.

28. *Self-Portrait.* 1918. Canvas, 60 × 54 cm. Paris, Private Collection.

29. *Sleeping Nude. c.*1916. Canvas, 94·9 × 194·9 cm. New York, Private Collection.

30. *Tea.* 1919. Canvas, 139·7 × 210·8 cm. Mr. and Mrs. David L. Loew, Beverly Hills, California.

31. *The Artist and his Model.* 1919. Canvas, 59·7 × 71·1 cm. New York, Dr. and Mrs. Harry Bakwin.

32. *The Hindu Pose.* 1923. Canvas, 72·5 × 59·5 cm. New York, Mr. and Mrs. Donald S. Stralem.

33. *Woman with a Veil.* 1927. Canvas, 61 × 50·2 cm. New York, Mr. and Mrs. William S. Paley.

34. *Lemons on a Pewter Plate.* 1927. Canvas, 54·6 × 65·4 cm. Chicago, Mr. and Mrs. Nathan Cummings.

35. *Reclining Nude, Back.* 1927. Canvas, 66 × 92·1 cm. Paris, Private Collection.

36. *Odalisques.* 1928. Canvas, 54·6 × 74·9 cm. New York, Mr. and Mrs. Ralph F. Colin.

37. *Pink Nude.* 1935. Canvas, 66 × 92·7 cm. The Baltimore Museum of Art (Cone Collection).

38. *The Dance* (first version). 1931–33. Left Panel: Canvas, 340 × 387 cm. Le Musée d'Art Moderne de la Ville de Paris.

39. *The Dream*. 1935. Canvas, 81 × 65·1 cm. New York, Private Collection.

40. *Dancer and Armchair, Black Background*. 1942. Canvas, 50·2 × 65·1 cm. New York, Private Collection.

41. *Music*. 1939. Canvas, 114·9 × 114·9 cm. Buffalo, The Albright-Knox Art Gallery.

42. *Lady in Blue*. 1937. Canvas, 92·7 × 73·7 cm. Philadelphia, Mrs. John Wintersteen.

43. *The Rococo Chair*. 1946. Canvas, 92·1 × 73 cm. Nice-Cimiez, Le Musée Matisse.

44. *The Silence Living in Houses*. 1947. Canvas, 54·9 × 46 cm. Paris, Private Collection.

45. *Plum Blossoms, Green Background*. 1948. Canvas, 116·2 × 88·9 cm. Private Collection.

46. *Still Life with Oranges*. c.1899. Canvas, 45·7 × 55·2 cm. Washington University, St. Louis, Missouri.

47. *The Snail*. 1953. Gouache on cut and pasted paper, 261 × 261·6 cm. London, Tate Gallery.

48. *The Negress*. 1952. Crayon, gouache on cut and pasted paper, 448·3 × 847·7 cm. Basle, Galerie Beyeler.

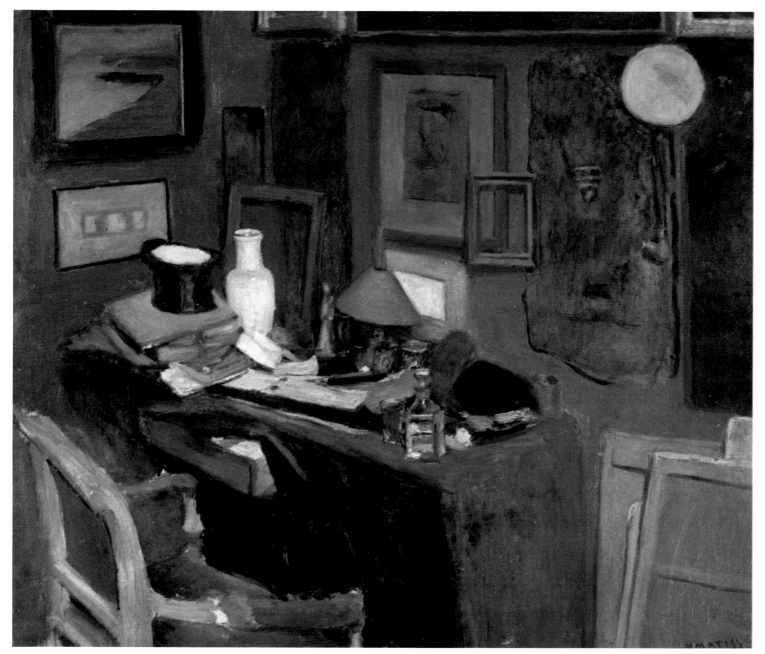

1. *Interior with a Top Hat.* 1896. Paris, Private Collection

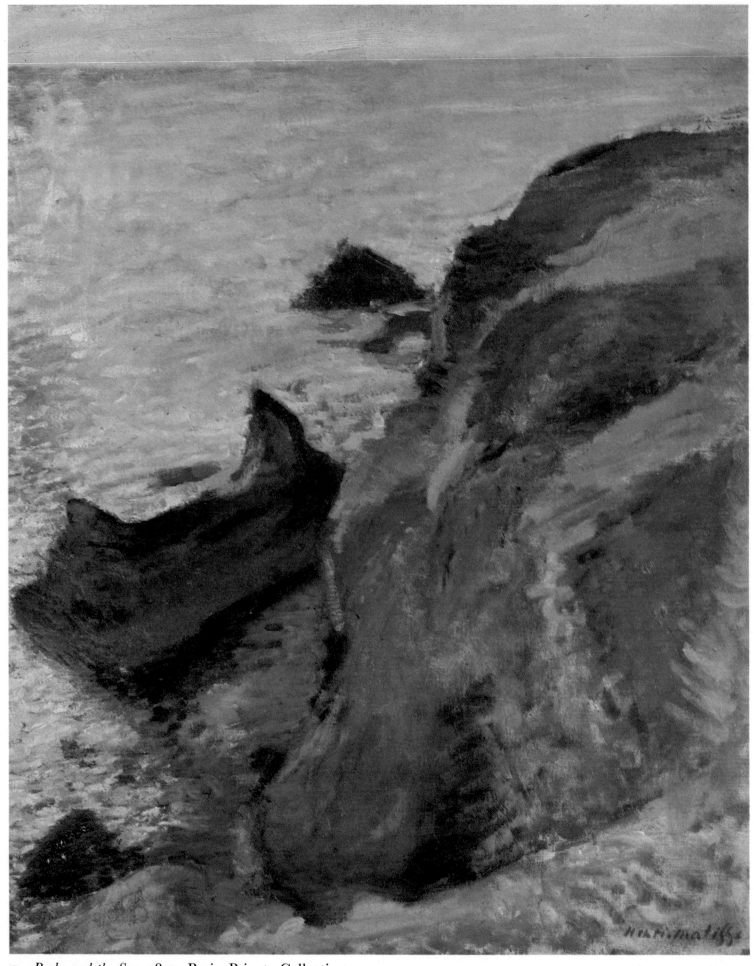

2. *Rocks and the Sea.* 1897. Paris, Private Collection

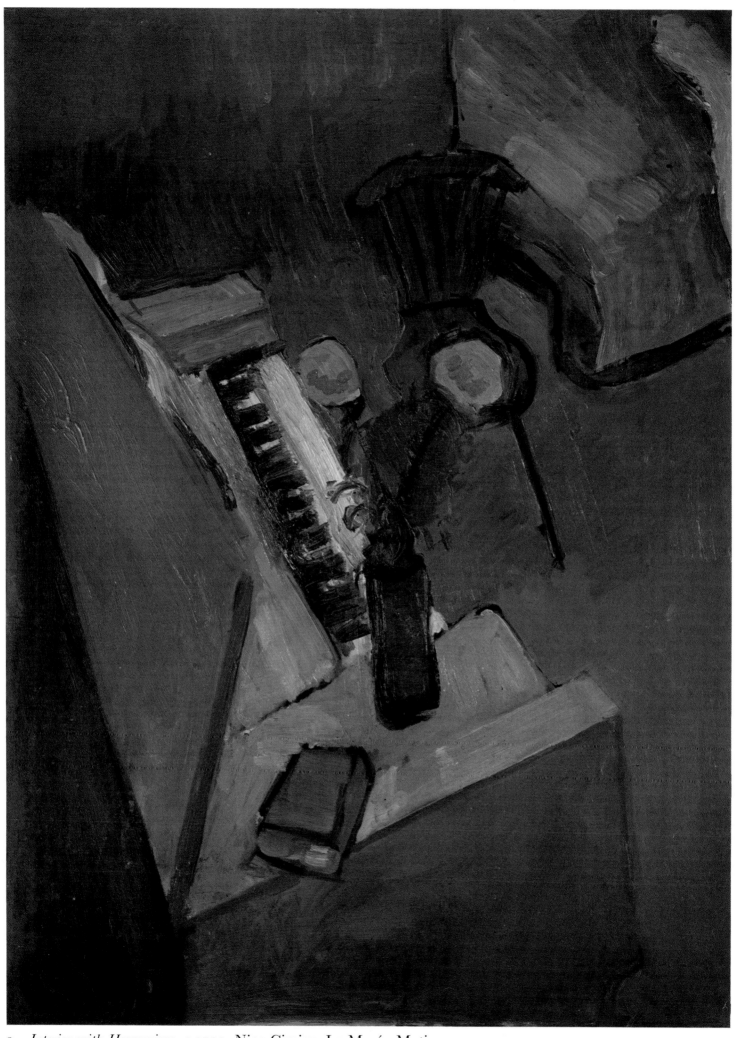

3. *Interior with Harmonium, c.*1900. Nice-Cimiez, Le Musée Matisse

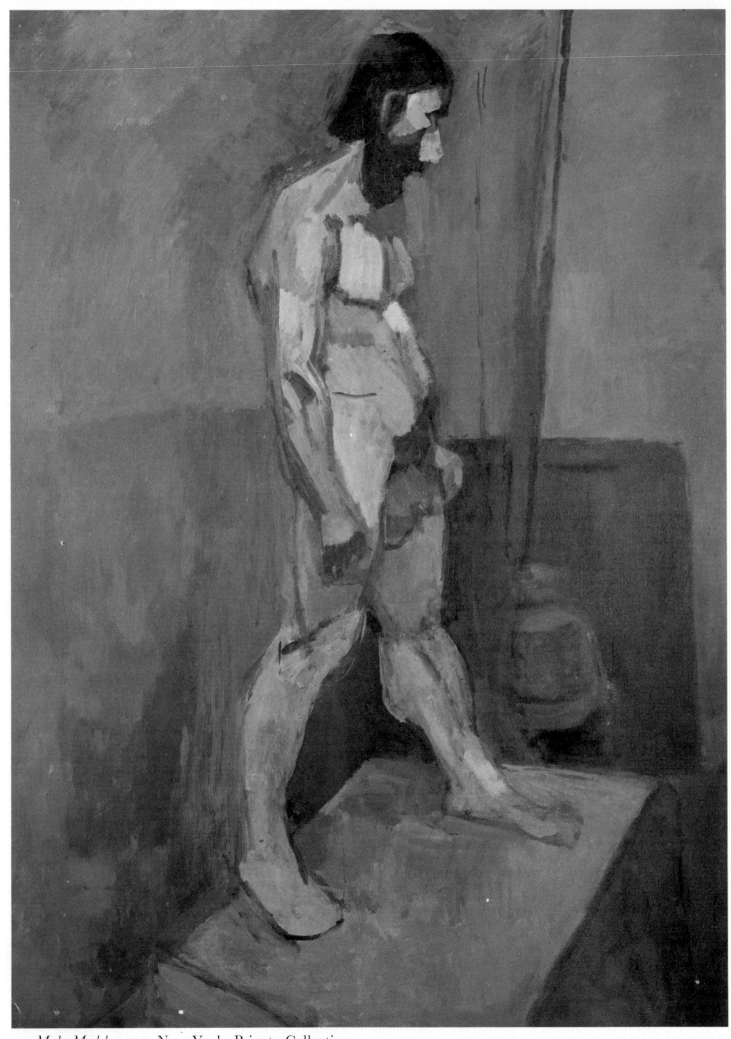

4. *Male Model.* 1900. New York, Private Collection

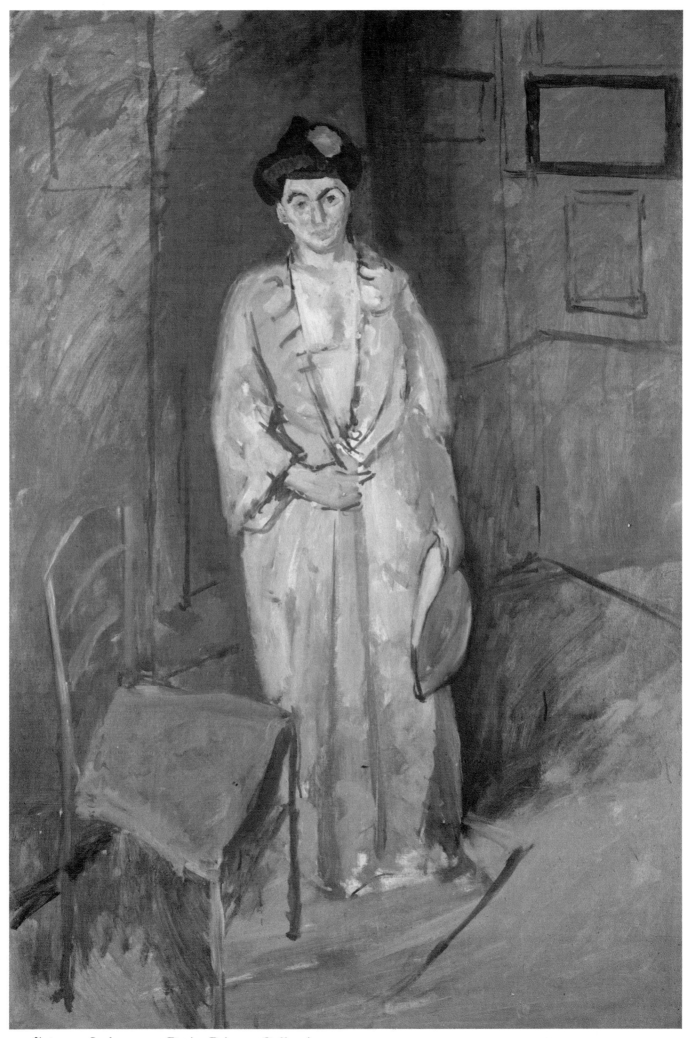

5. *Japanese Lady*. 1901. Paris, Private Collection

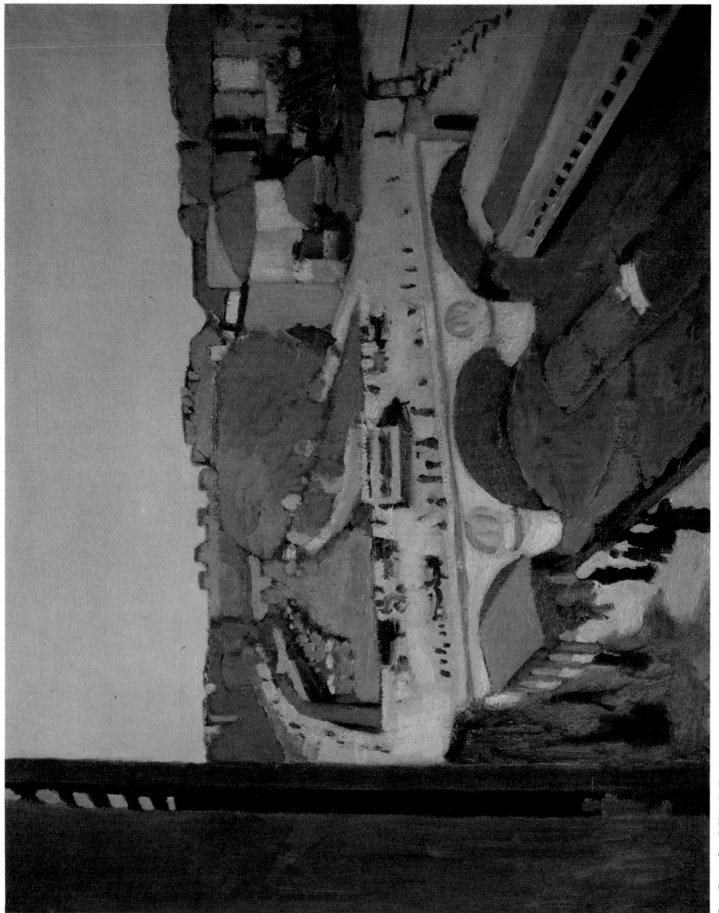

6. *Pont St. Michel.* Paris, 1900. New York, Mr. and Mrs. William A. M. Burden

7. *Path in the Bois de Boulogne*. 1902. Moscow, The Pushkin Museum of Fine Art

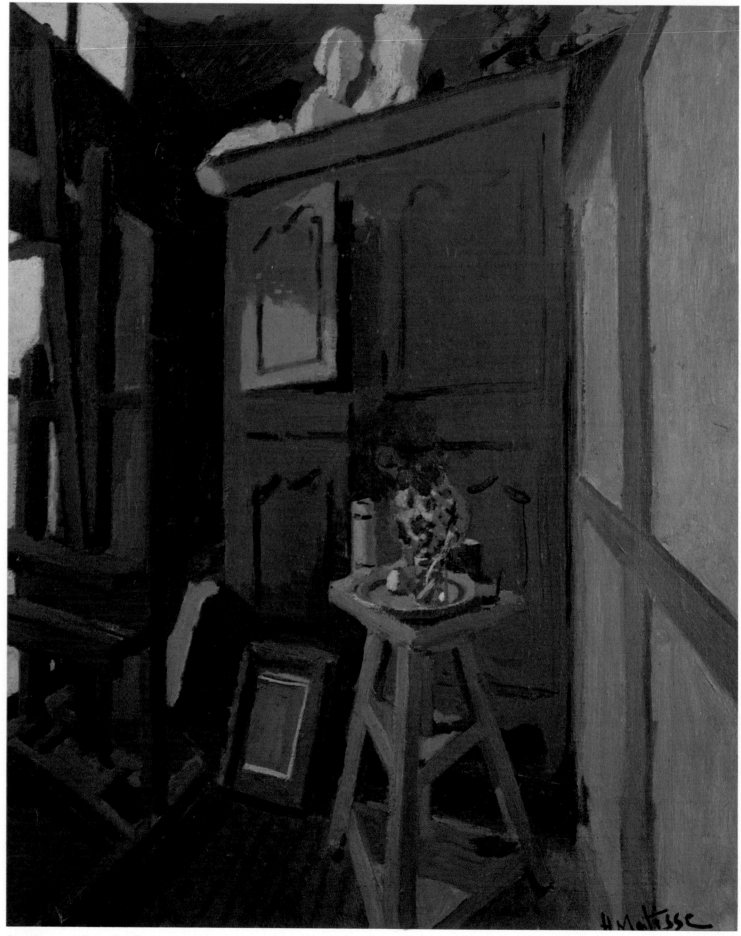

8. *Corner of the Studio, c.*1900. London, Lord Amulree

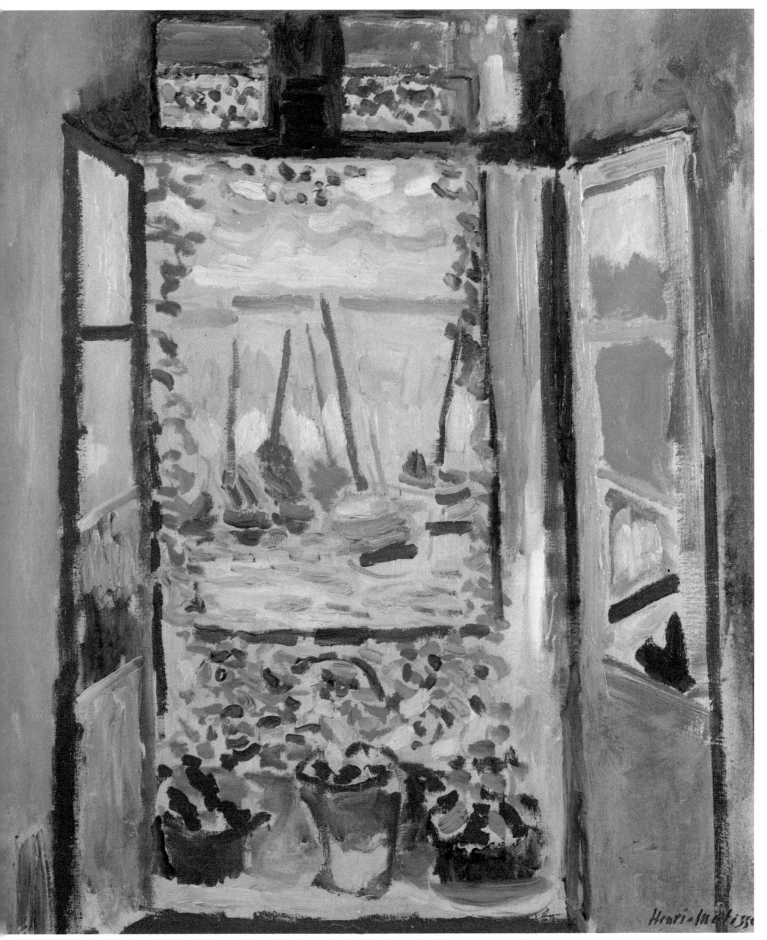

Open Window, Collioure. 1905. New York, Mr. and Mrs. John Hay Whitney

10. *Landscape at Collioure*. 1905. Leningrad, The State Hermitage Museum

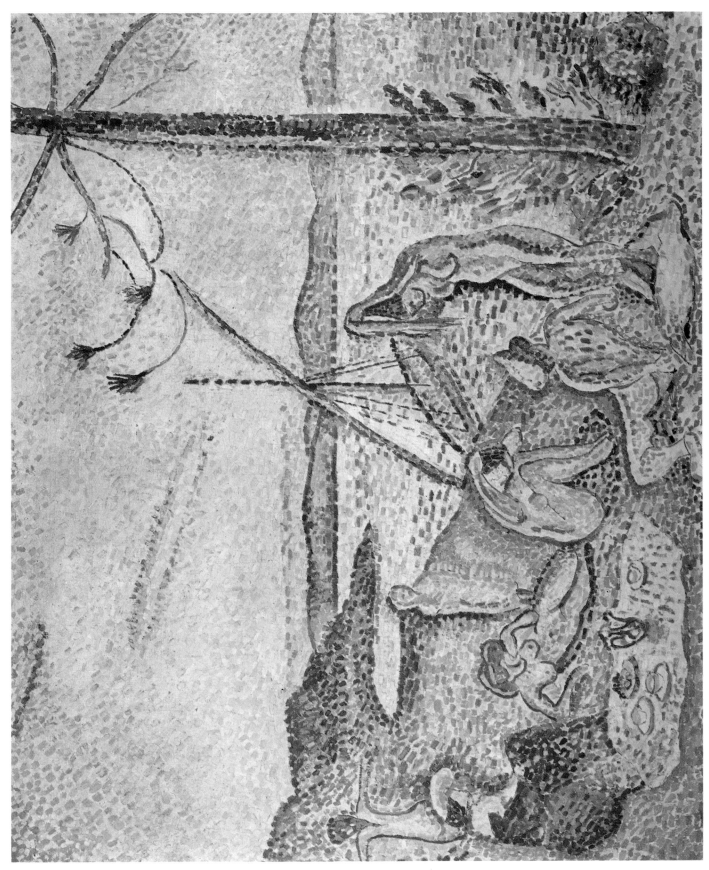

11. *Luxe, Calme et Volupté*. 1904–5. Paris, Private Collection

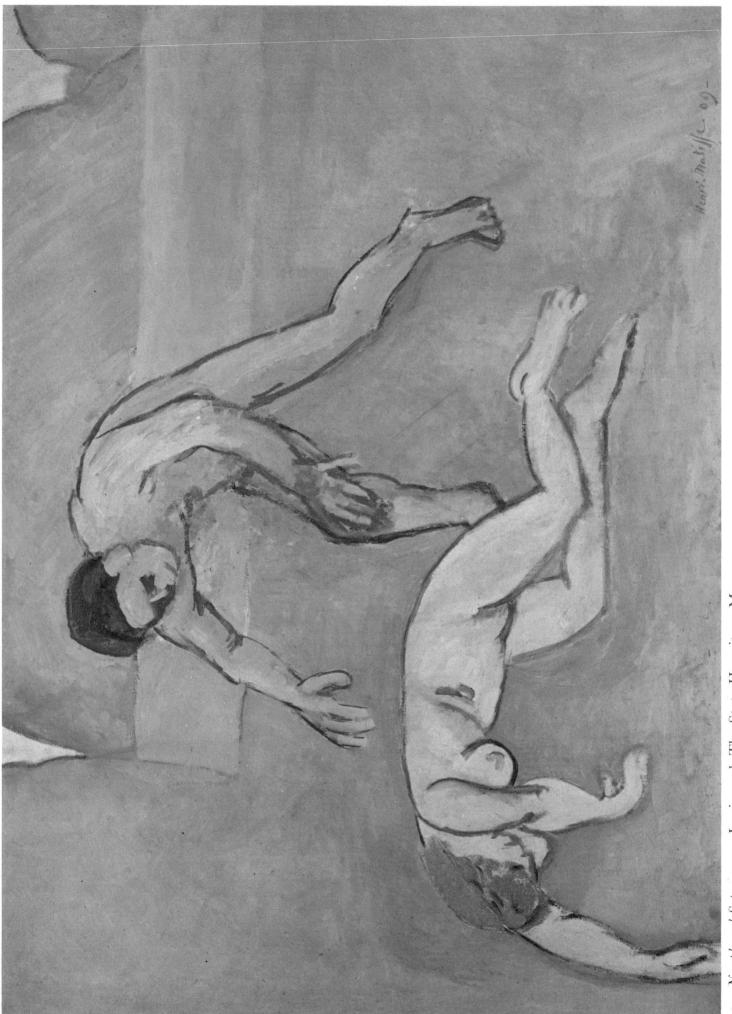

12. *Nymph and Satyr.* 1909. Leningrad, The State Hermitage Museum

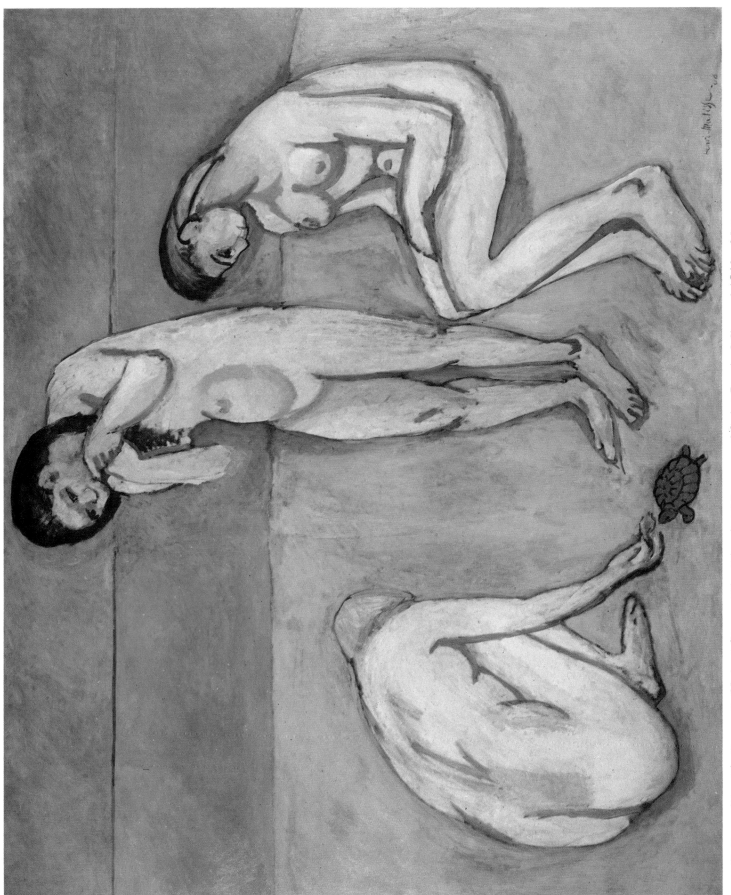

13. *Bathers with a Turtle*. 1908. United States, The City Art Museum of Saint Louis, Missouri (Gift of Mr. and Mrs. Joseph Pulitzer, Jr.)

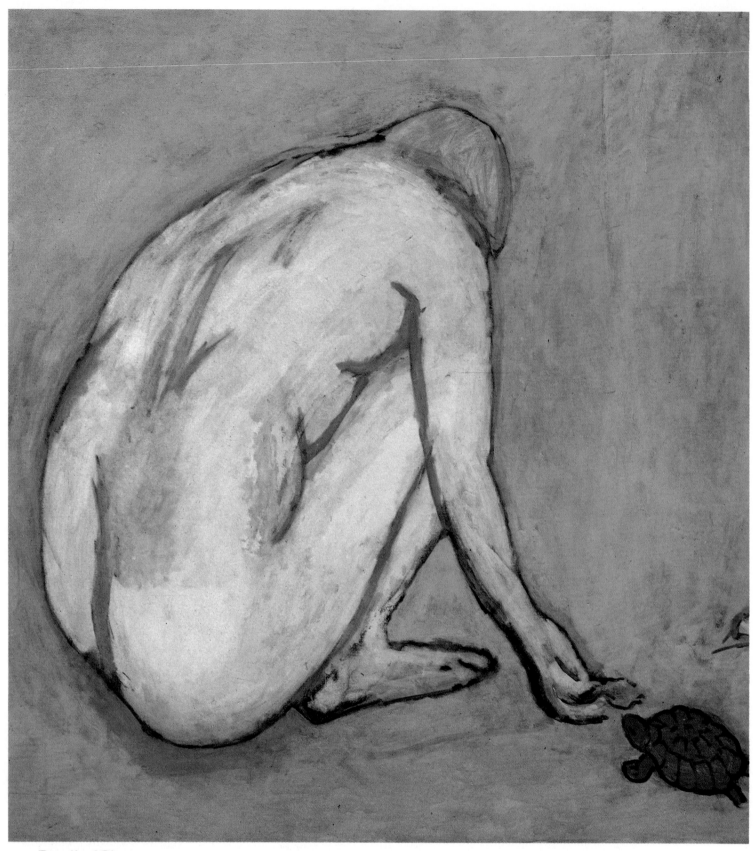

14. Detail of Plate 13

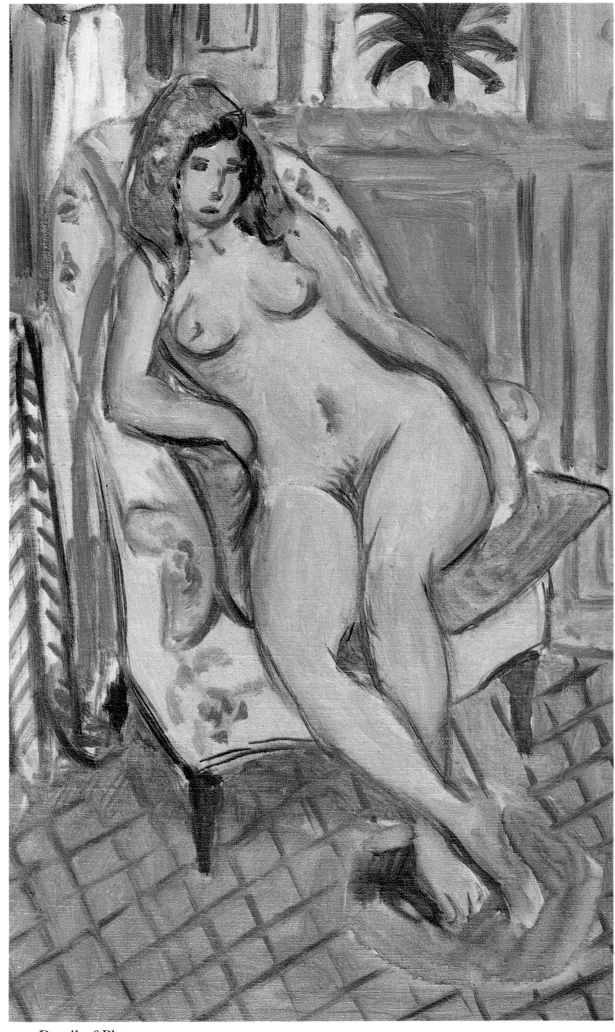

15. Detail of Plate 31

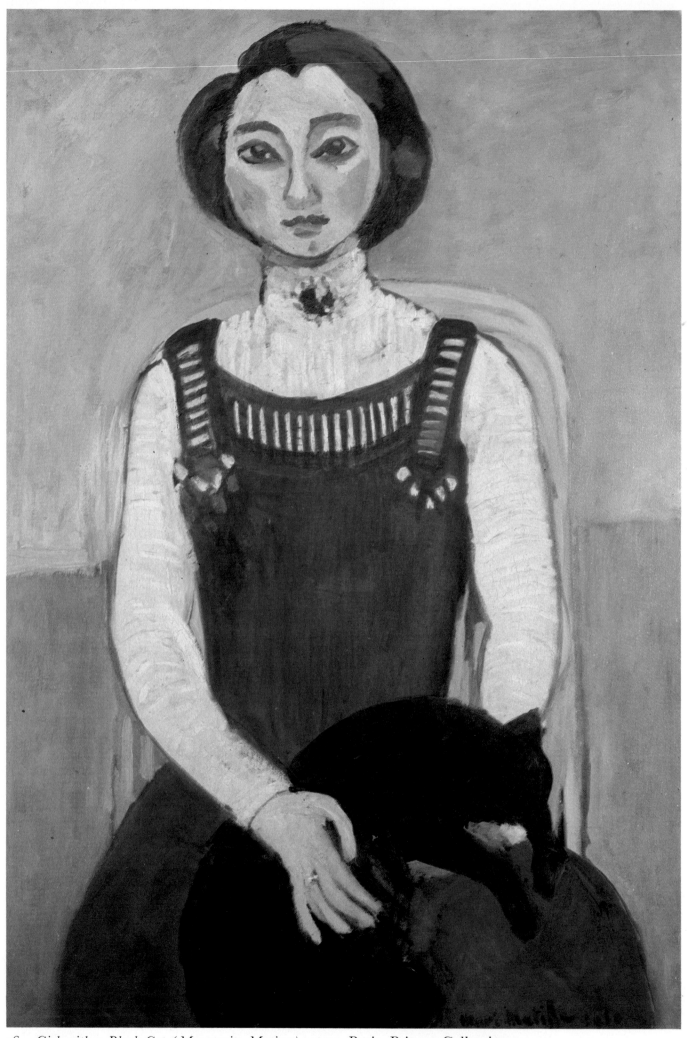

16. *Girl with a Black Cat (Marguerite Matisse)*. 1910. Paris, Private Collection

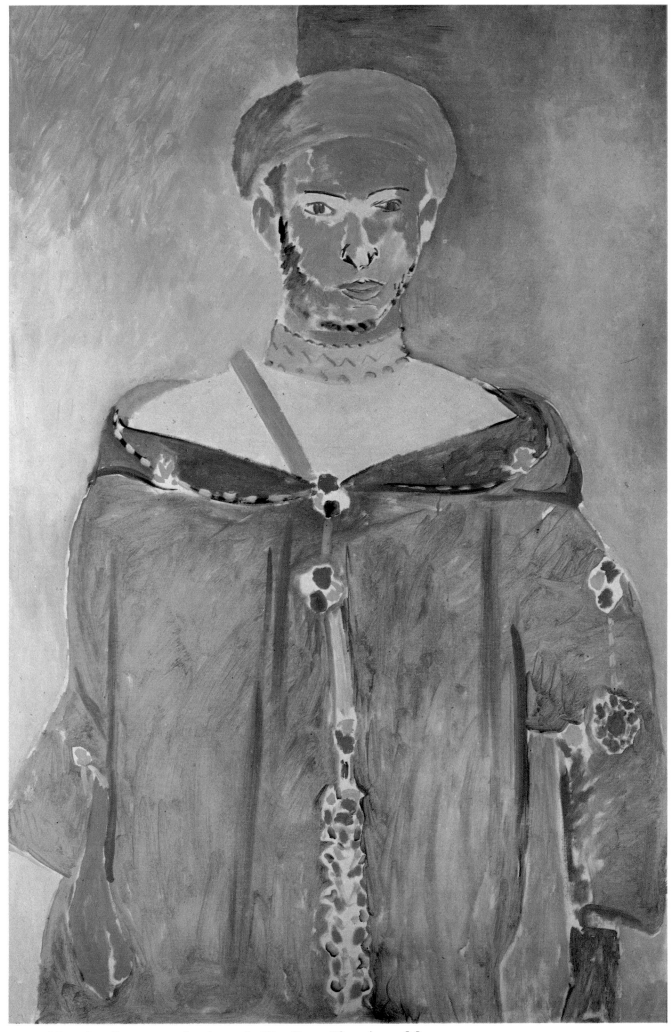

17. *Riffian Standing*. 1912. Leningrad, The State Hermitage Museum

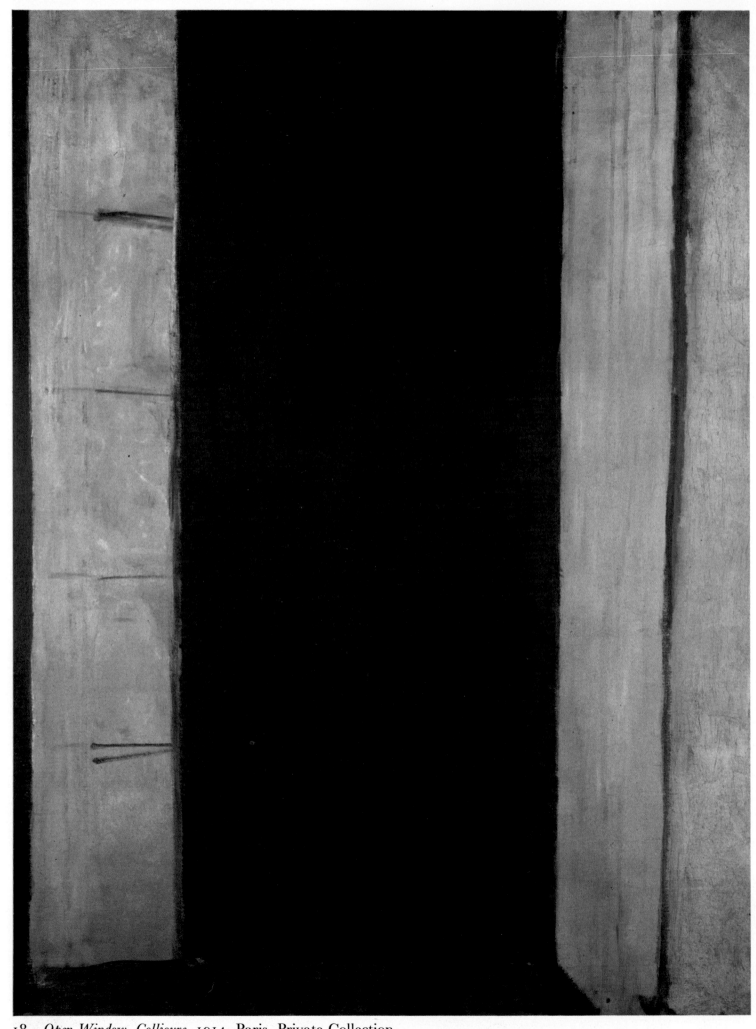

18. *Open Window, Collioure.* 1914. Paris, Private Collection

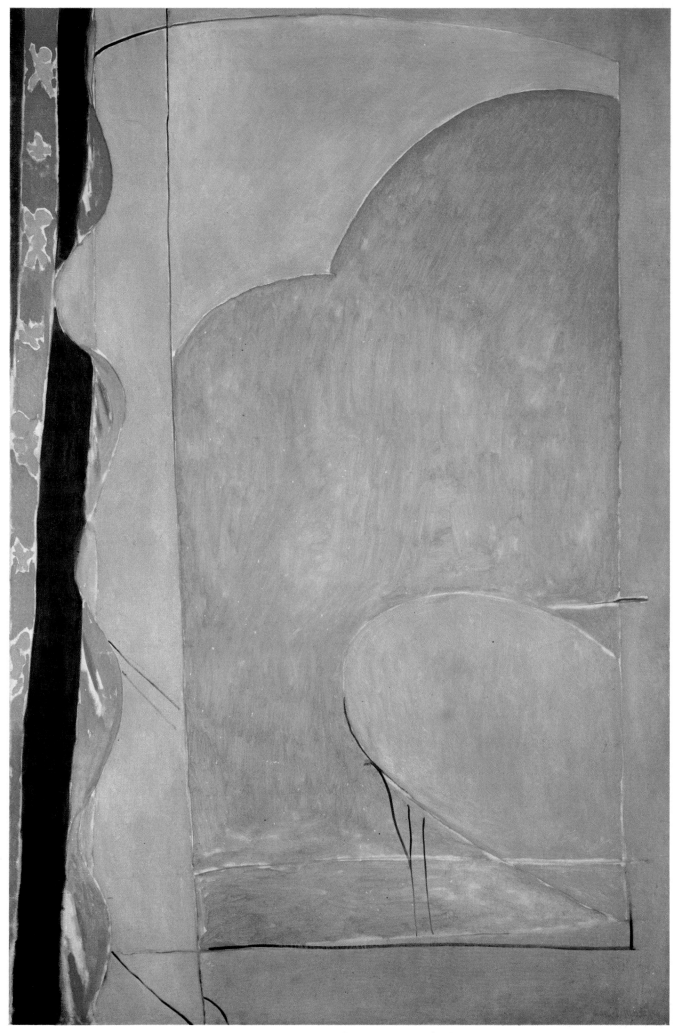

19. *Composition, The Yellow Curtain*. 1915. Brussels, Monsieur Mabille

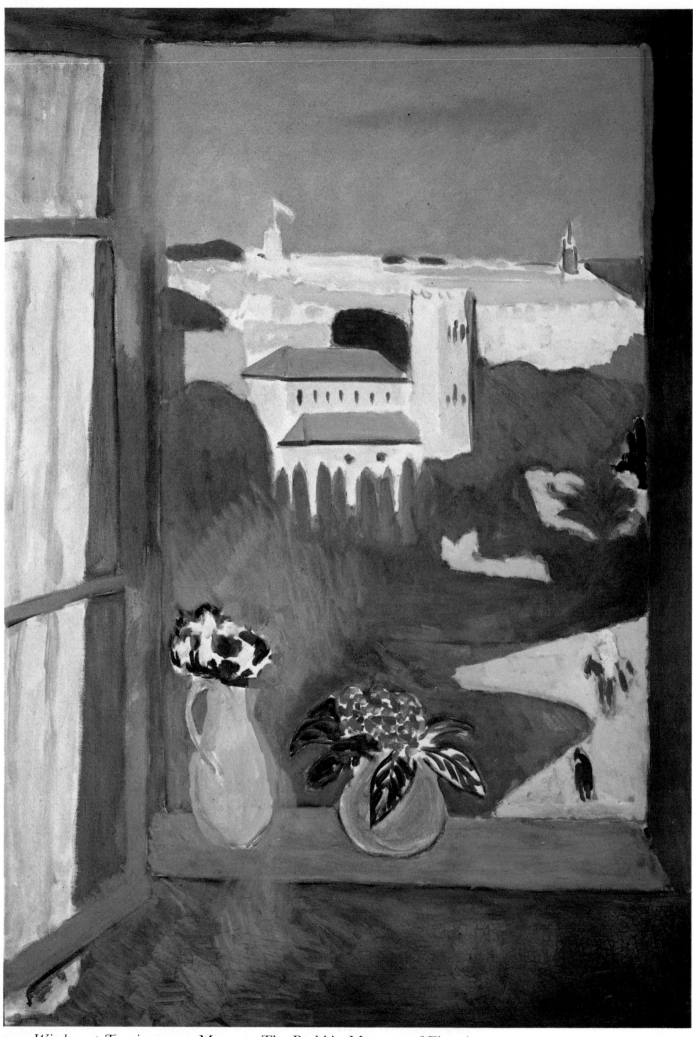

20. *Window at Tangier*. 1912. Moscow, The Pushkin Museum of Fine Art

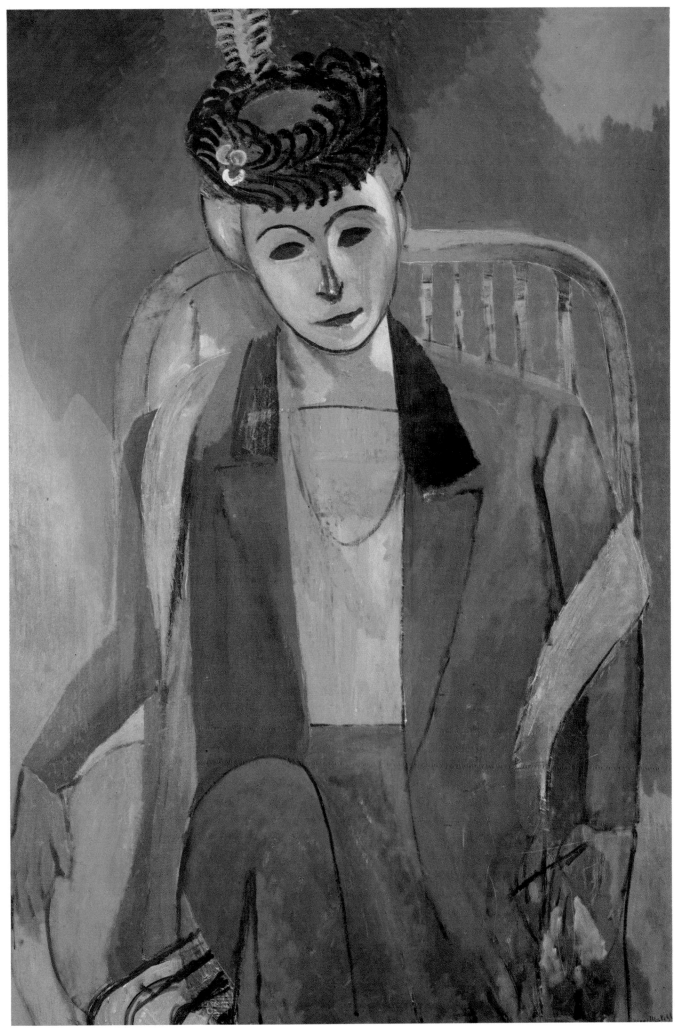

21. *Portrait of Madame Matisse.* 1913. Leningrad, The State Hermitage Museum

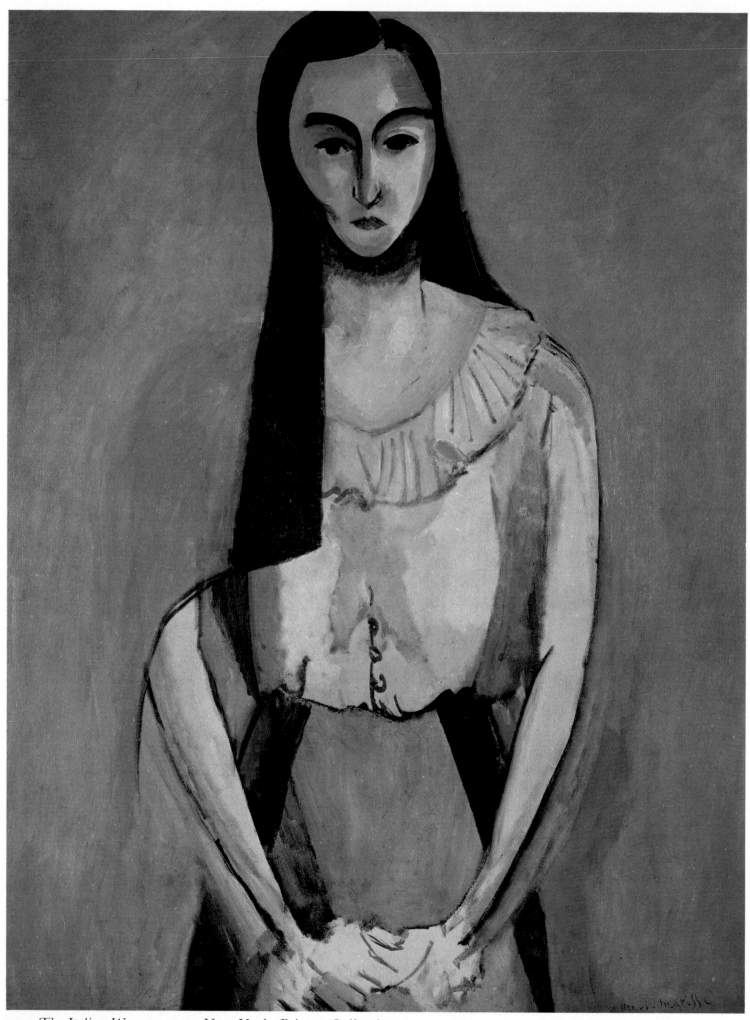

22. *The Italian Woman.* 1915. New York, Private Collection

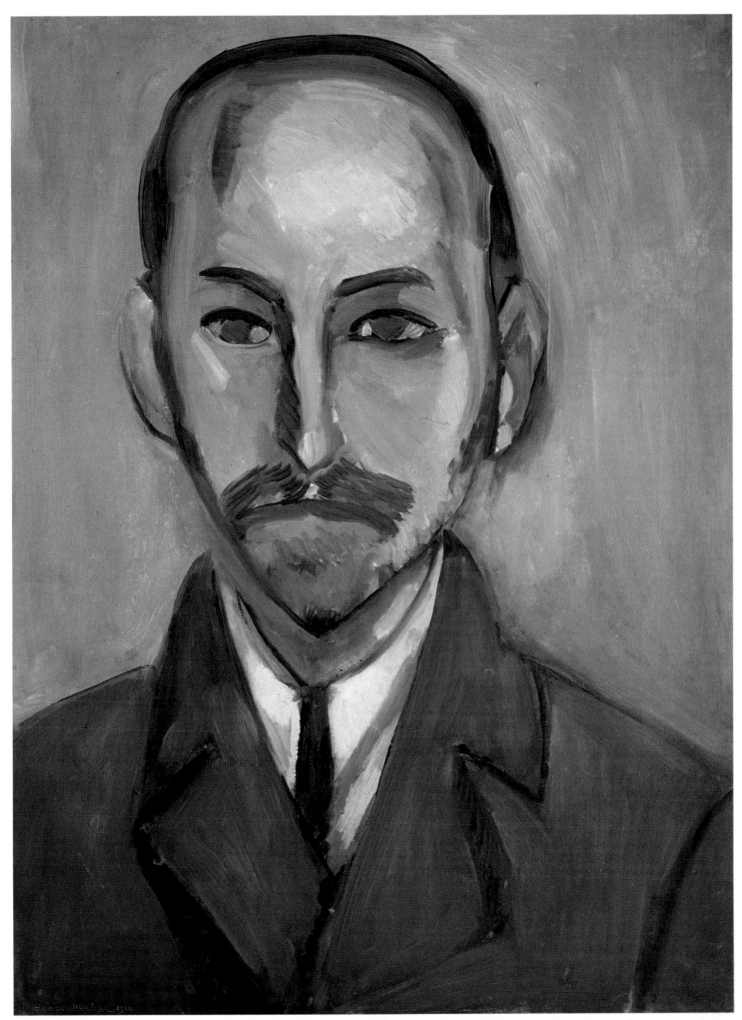

23. *Portrait of Michael Stein.* 1916. The San Francisco Museum of Art (Gift of Nathan Cummings)

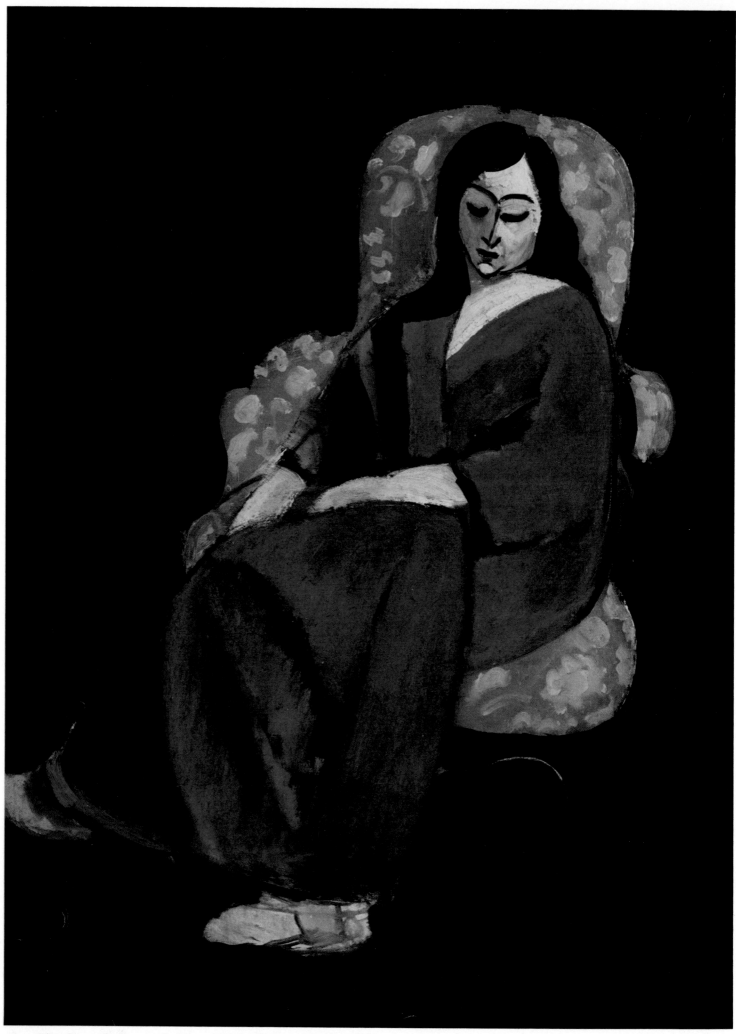

24. *The Green Robe.* 1916. New York, Private Collection

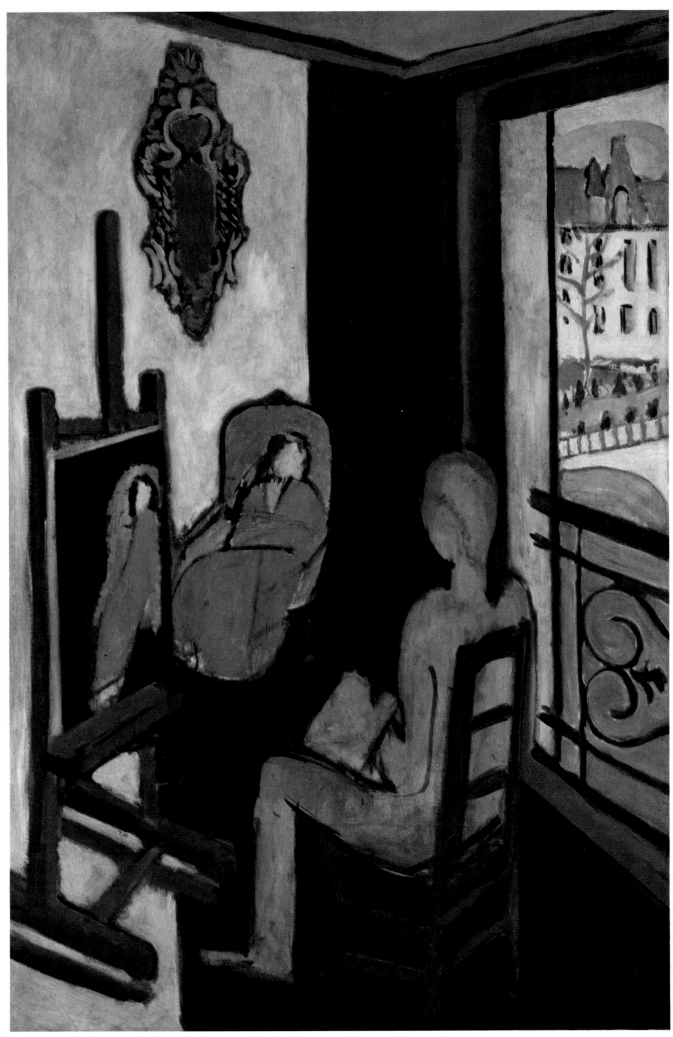

25. *The Painter and his Model.* 1917. Paris, Centre Georges Pompidou

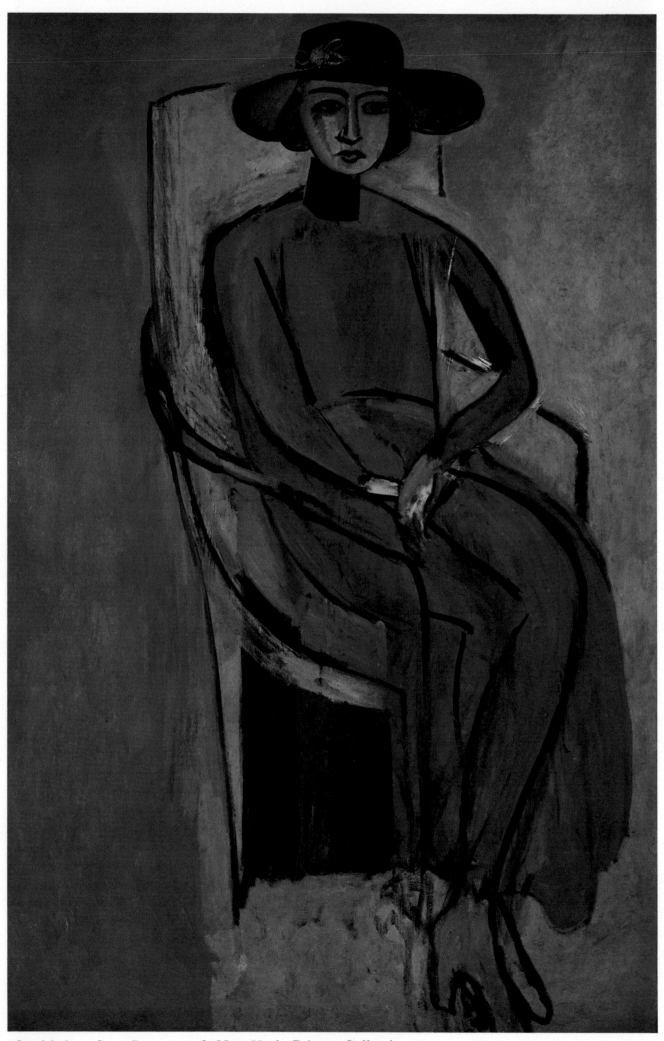

26. *Madame Greta Prozor*. 1916. New York, Private Collection

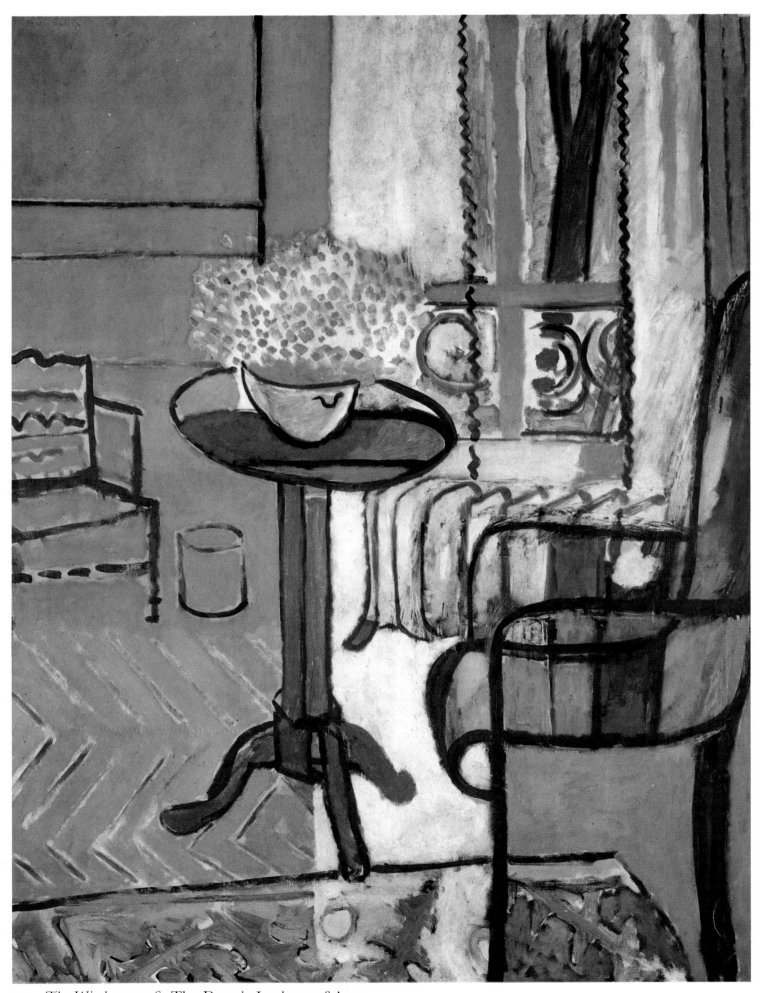

27. *The Window*. 1916. The Detroit Institute of Arts

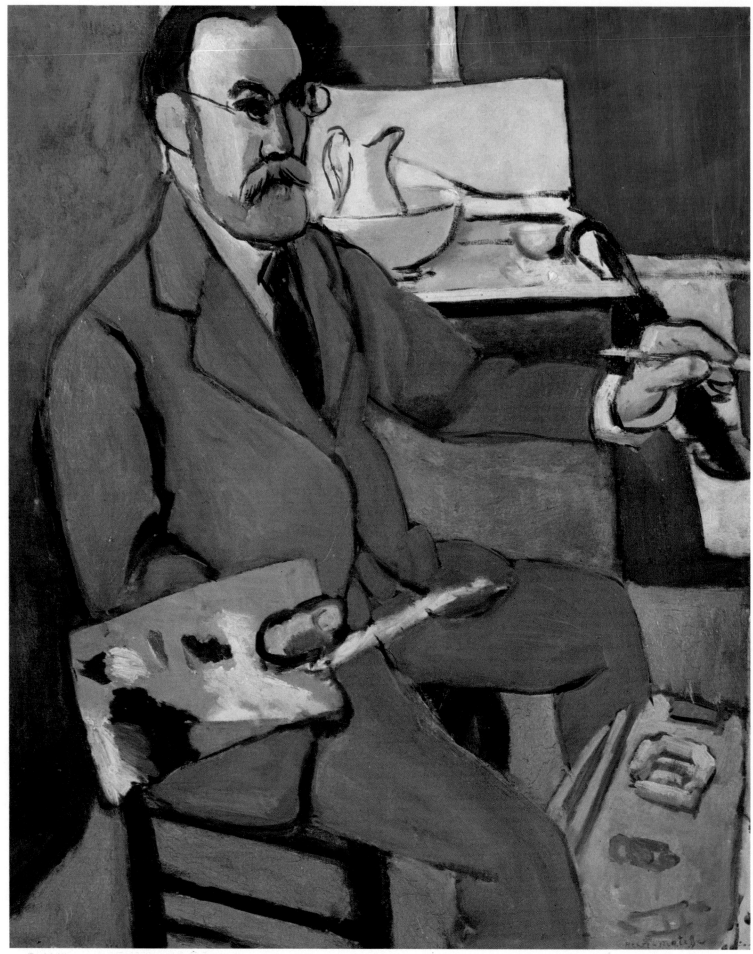

28. *Self-Portrait*. 1918. Paris, Private Collection

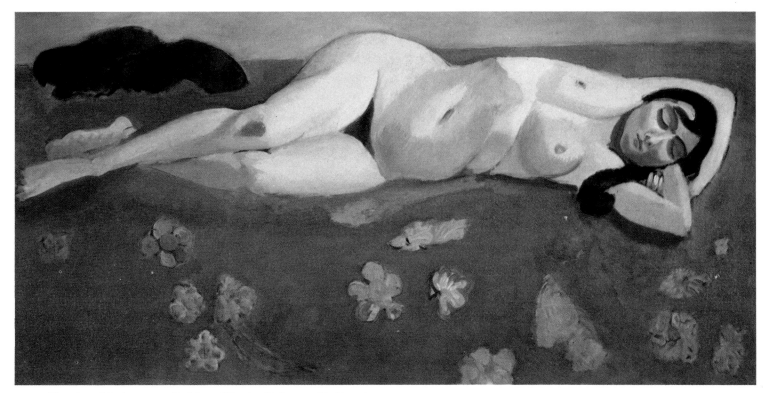

29. *Sleeping Nude.* *c.*1916. New York, Private Collection

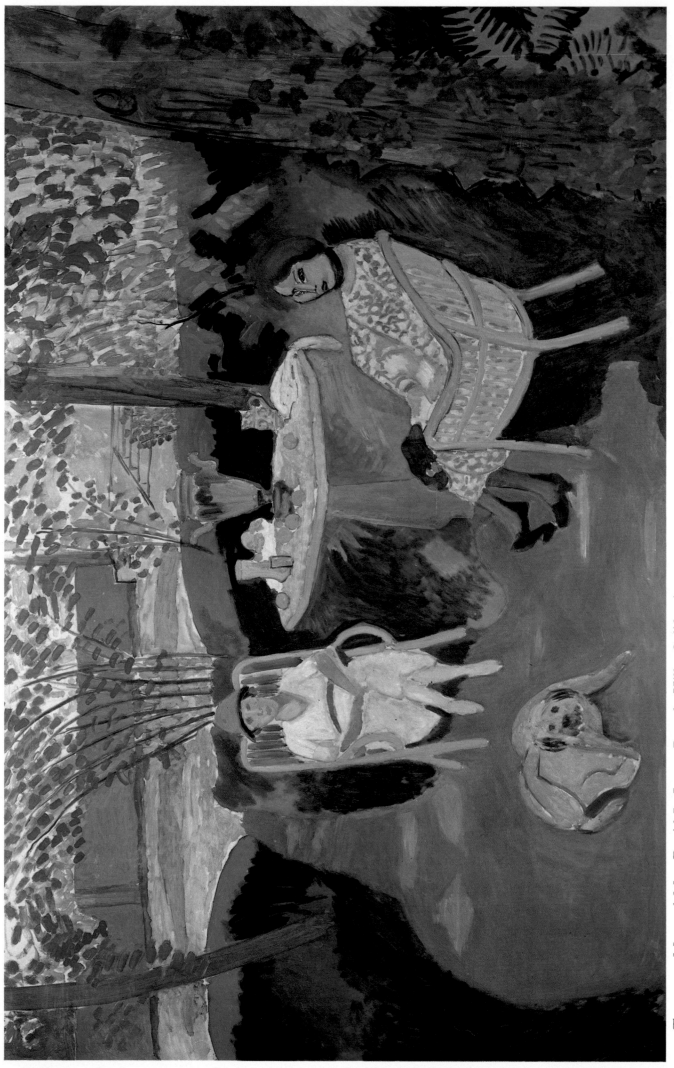

30. *Tea*. 1919. Mr. and Mrs. David L. Loew, Beverly Hills, California

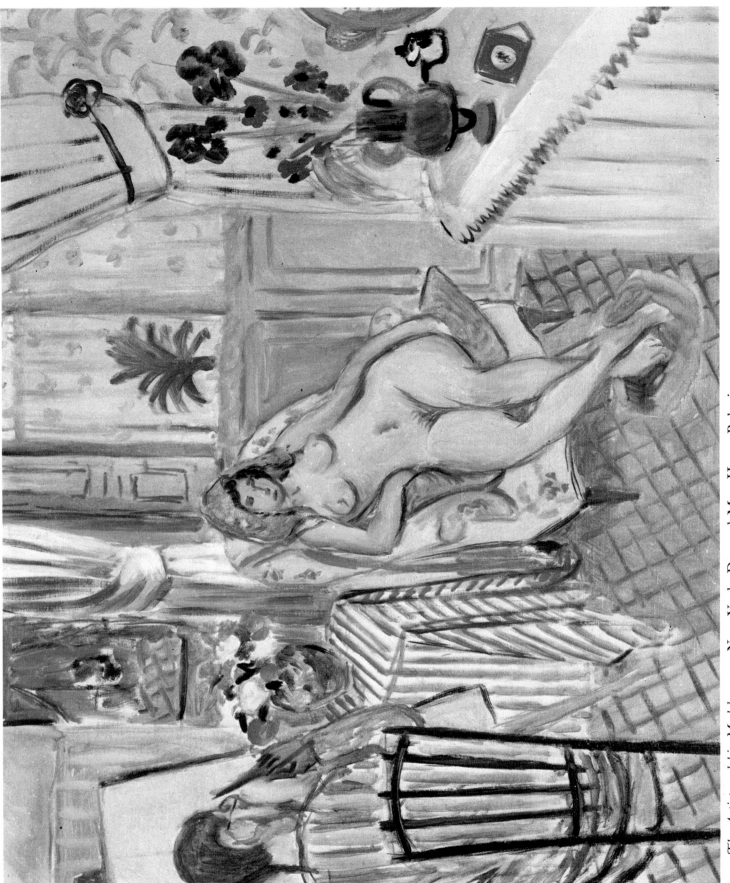

31. *The Artist and his Model*. 1919. New York, Dr. and Mrs. Harry Bakwin

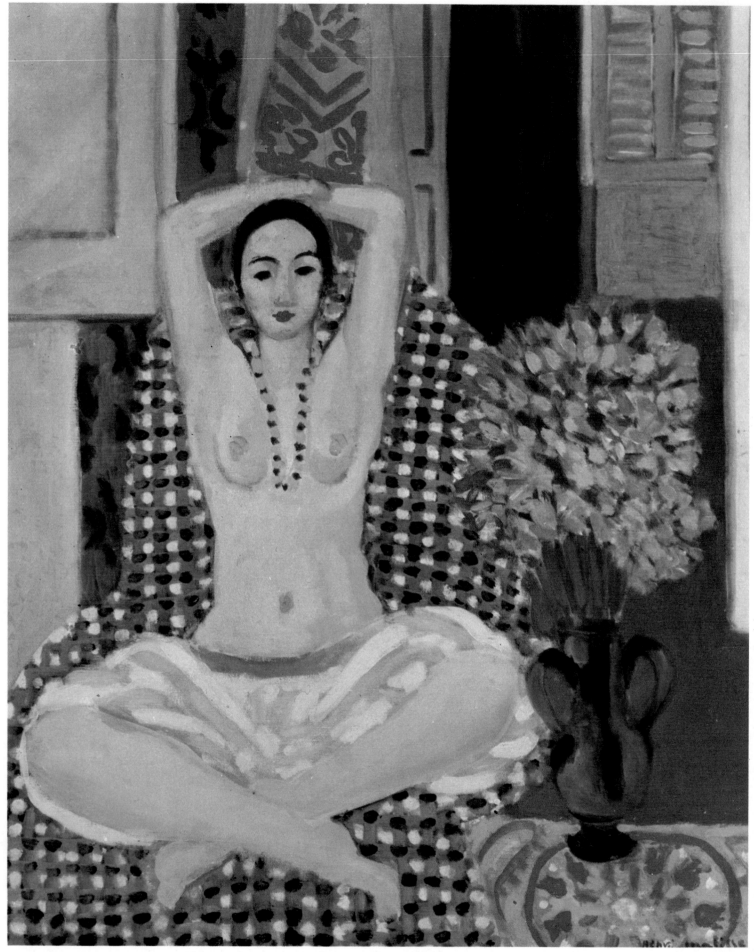

32. *The Hindu Pose.* 1923. New York, Mr. and Mrs. Donald S. Stralem

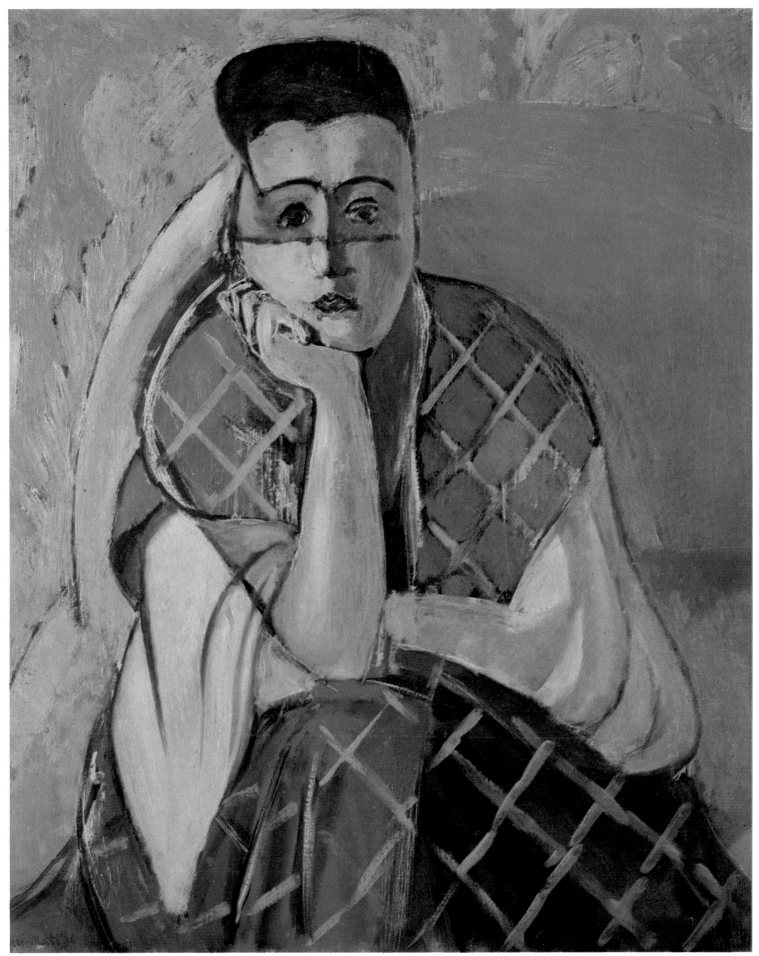

33. *Woman with a Veil*. 1927. New York, Mr. and Mrs. William S. Paley

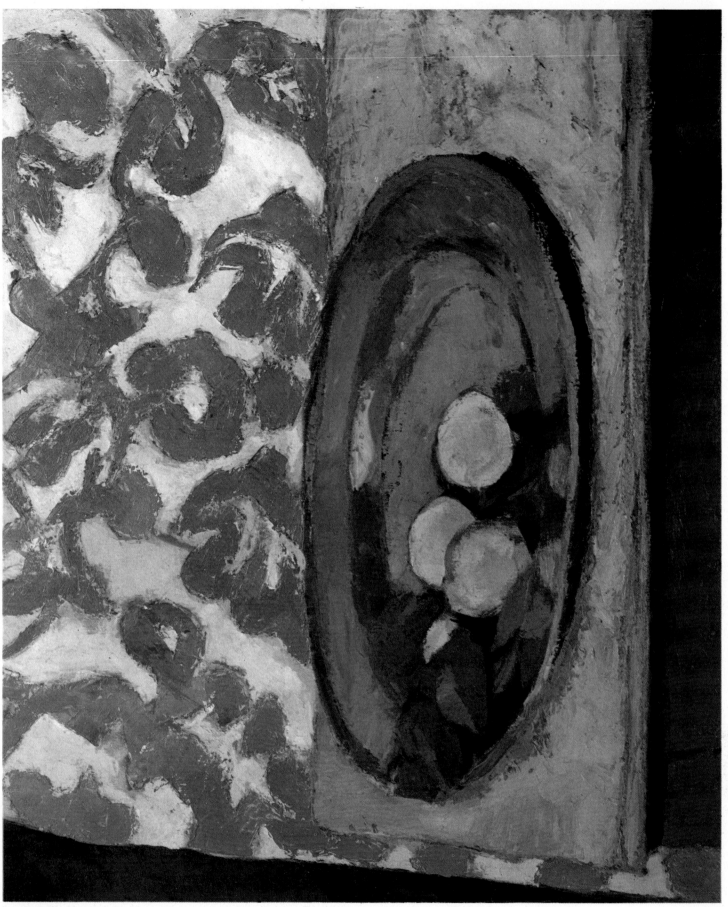

34. *Lemons on a Pewter Plate.* 1927. Chicago, Mr. and Mrs. Nathan Cummings

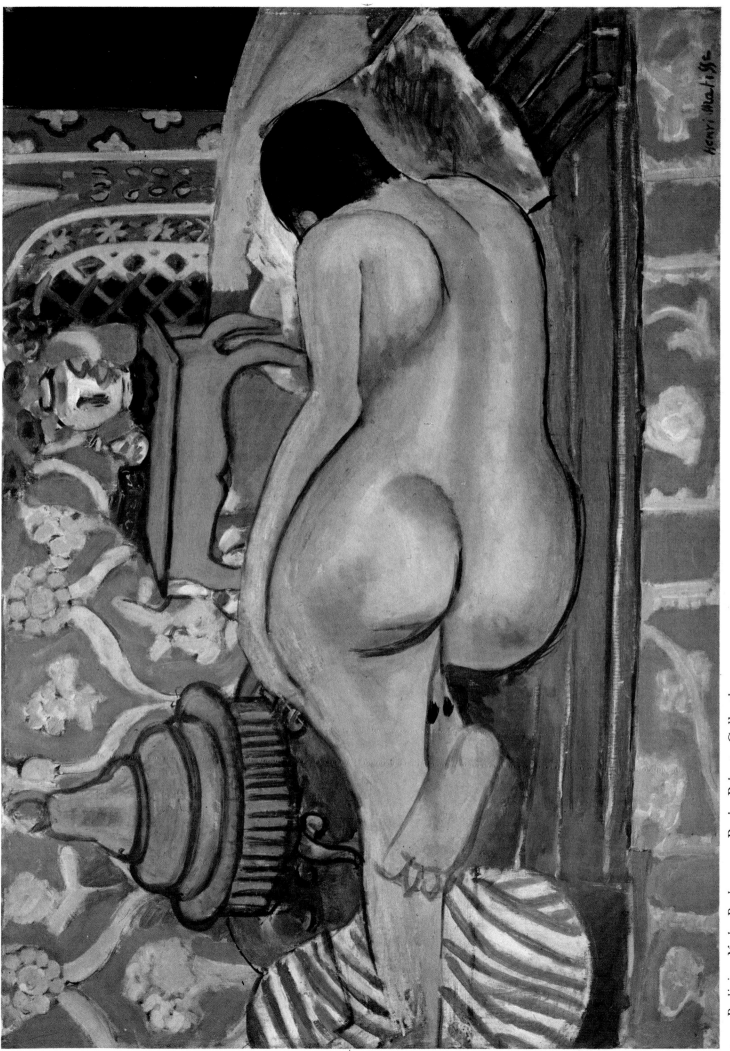

35. *Reclining Nude, Back.* 1927. Paris, Private Collection

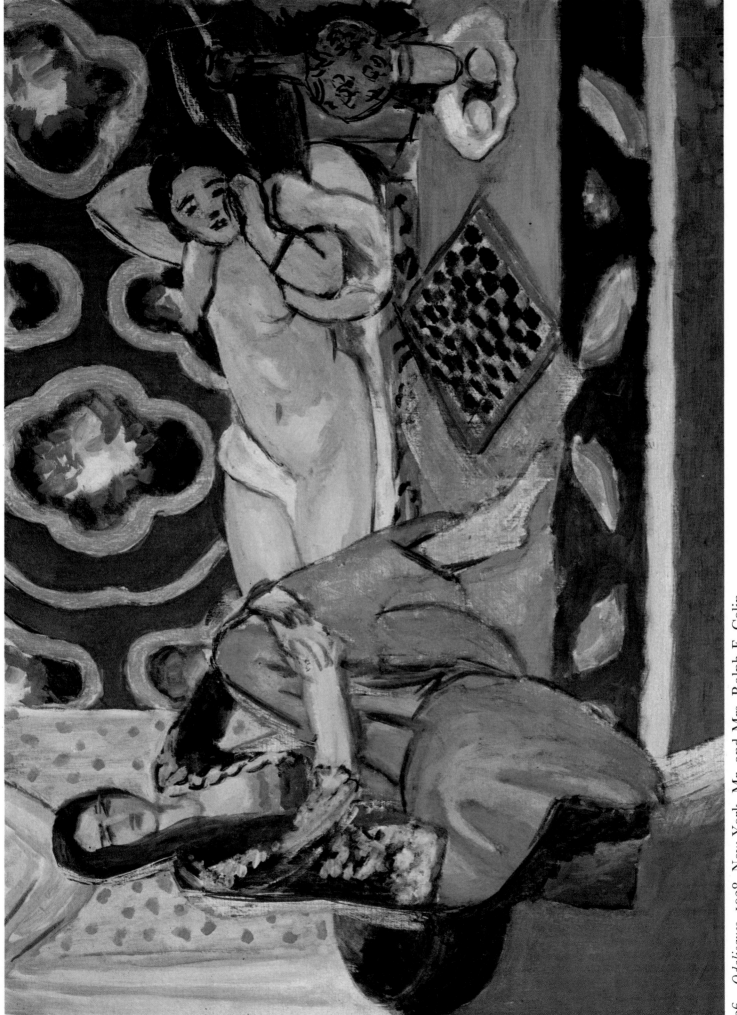

36. *Odalisques*. 1928. New York, Mr. and Mrs. Ralph F. Colin

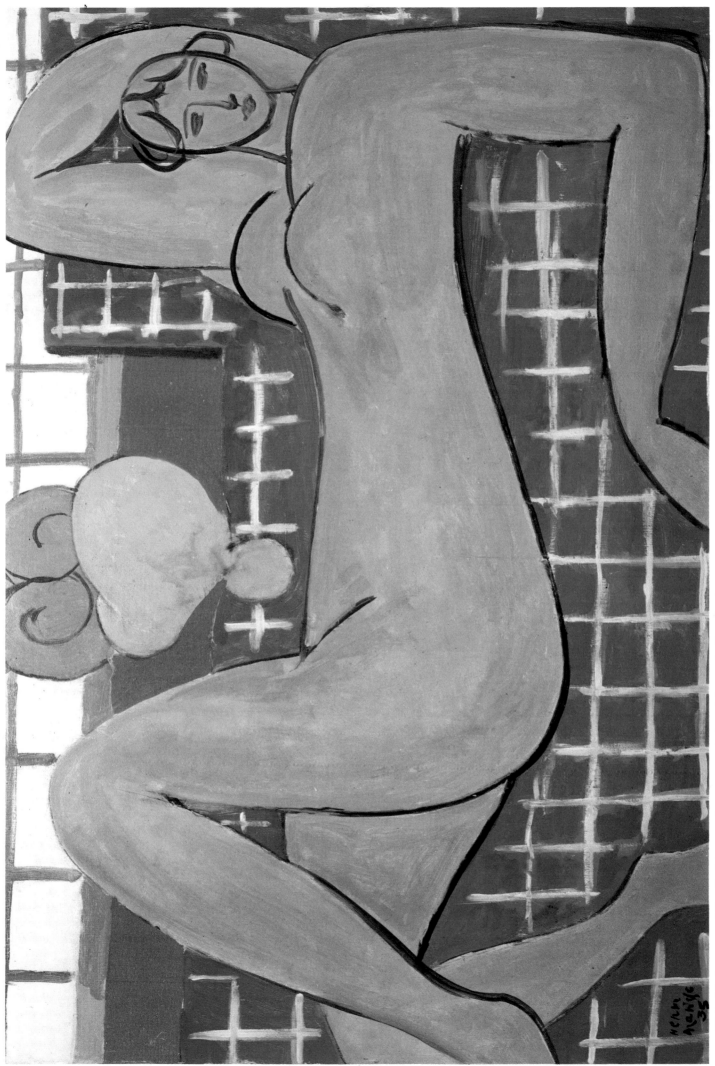

37. *Pink Nude*. 1935. The Baltimore Museum of Art (Cone Collection)

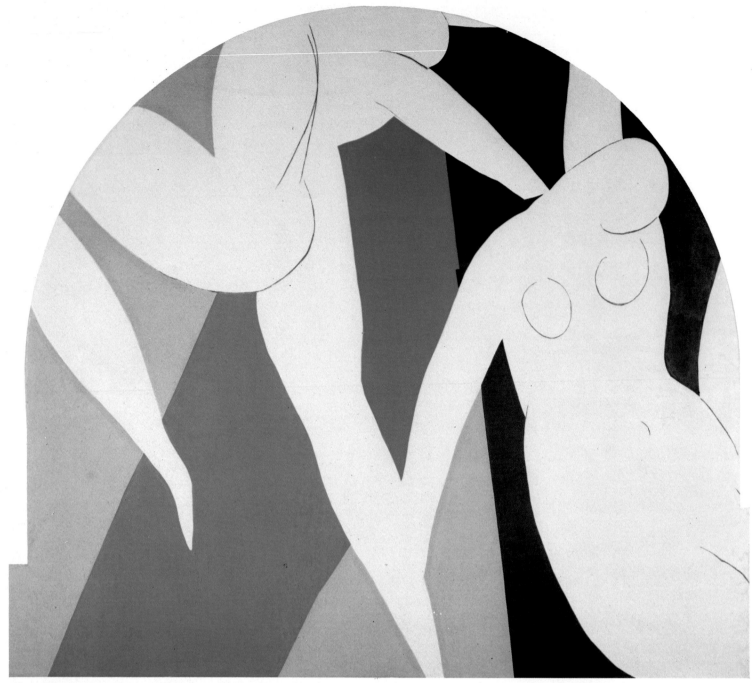

38. *The Dance (first version).* 1931–33. Left Panel. Le Musée d'Art Moderne de la Ville de Paris

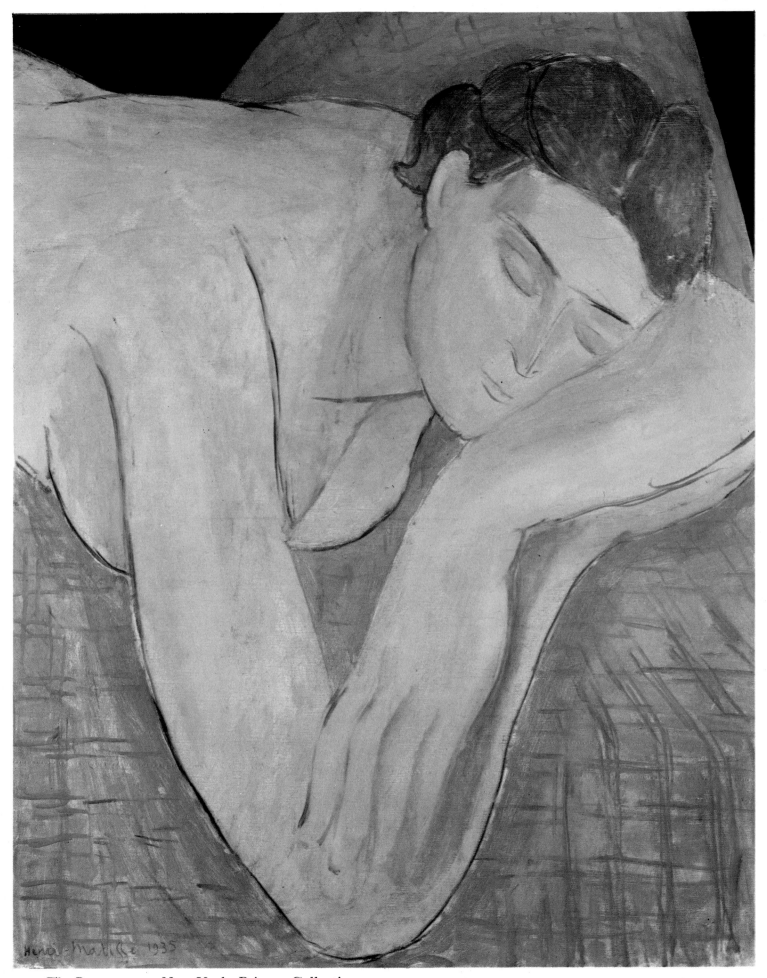

39. *The Dream*. 1935. New York, Private Collection

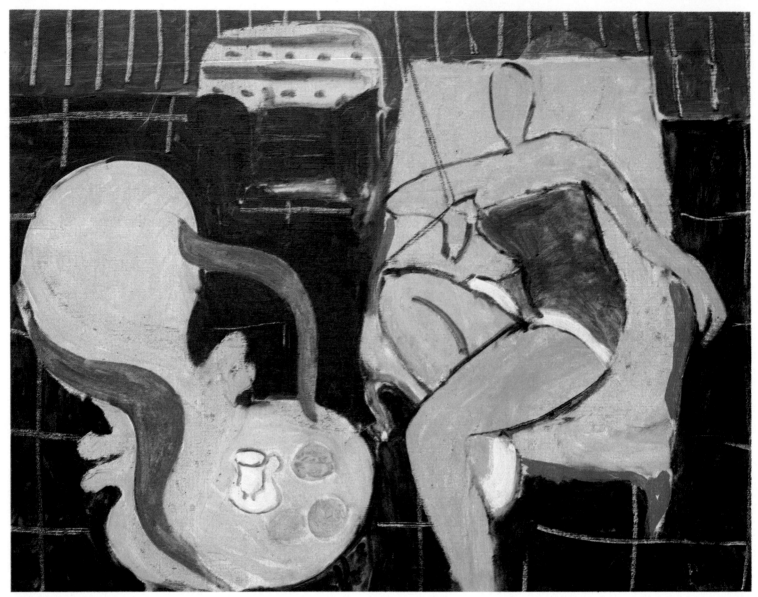

40. *Dancer and Armchair, Black Background.* 1942. New York, Private Collection

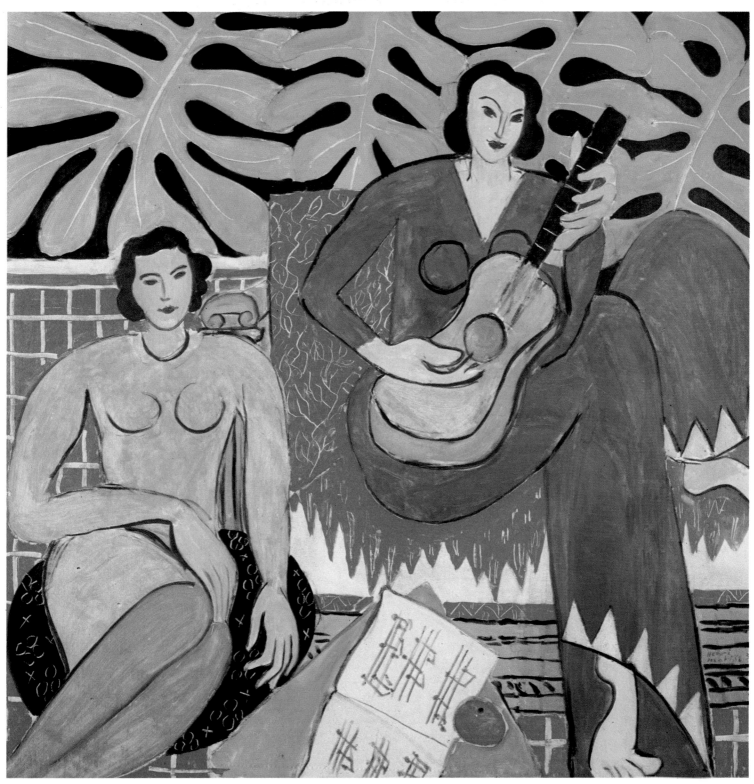

41. *Music*. 1939. Buffalo, The Albright-Knox Art Gallery

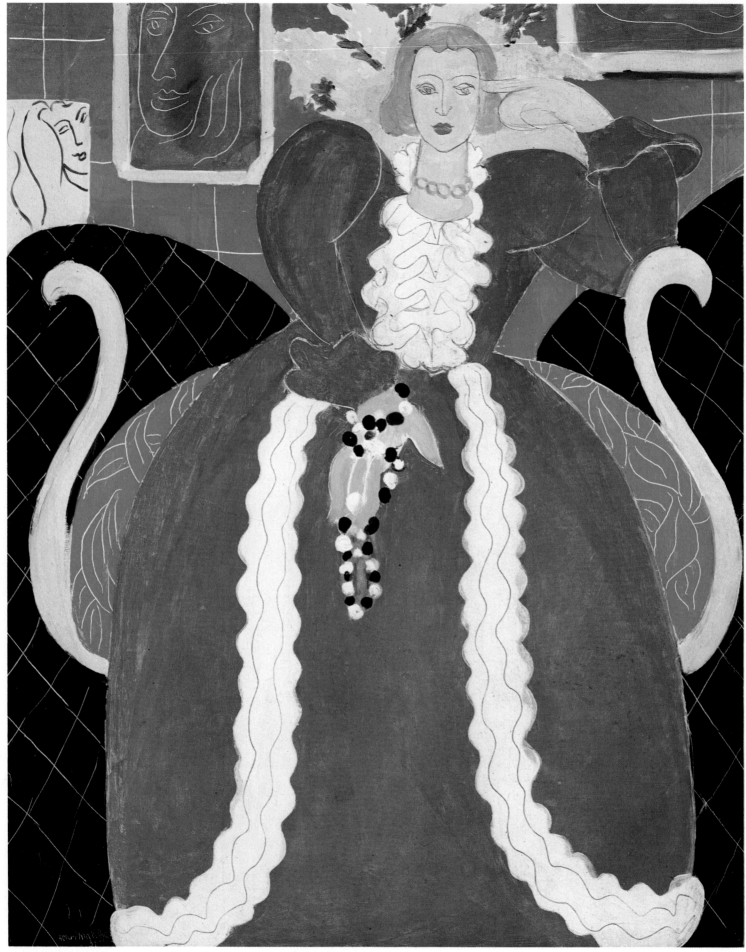

42. *Lady in Blue.* 1937. Philadelphia, Mrs. John Wintersteen

43. *The Rococo Chair.* 1946. Nice-Cimiez, Le Musée Matisse

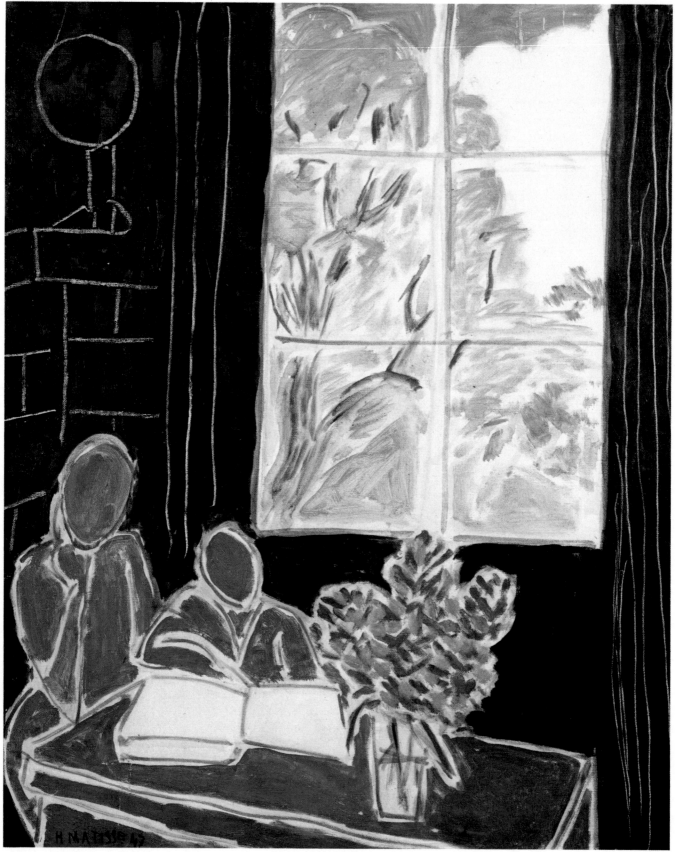

44. *The Silence Living in Houses.* 1947. Paris, Private Collection